THE POCKET IDIOT'S GUIDE™ TO

Photography

D1009315

by Roger Woodson

alpha
books

A Division of Macmillan General Reference
1633 Broadway, 7th Floor, New York NY 10019

Copyright ©1998 Roger Woodson

Macmillan Publishing books may be purchased for business or sales promotional use. For information please write: Special Markets Department, Macmillan Publishing USA, 1633 Broadway, New York, NY, 10019.

THE POCKET IDIOT'S GUIDE name and design are trademarks of Macmillan, Inc.

International Standard Book Number: 0-02-862129-8
Library of Congress Catalog Card Number: 97-80974

2000 8 7 6 5 4

Interpretation of the printing code: the rightmost number of the first series of numbers is the year of the book's printing; the rightmost number of the second series of numbers is the number of the book's printing. For example, a printing code of 98-1 shows that the first printing occurred in 1998.

Printed in the United States of America

Alpha Development Team

Brand Manager
Kathy Nebenhaus

Executive Editor
Gary M. Krebs

Managing Editor
Bob Shuman

Senior Editor
Nancy Mikhail

Development Editor
Jennifer Perillo

Editorial Assistant
Maureen Horn

Production Team

Development Editor
J.C. Choi

Production Editor
Stephanie Mohler

Cover Designer
Mike Freeland

Illustrator
Judd Winick

Designer
Glenn Larsen

Indexer
Sandra Henselmeier

Production Supervisor
Andrew Stone

Production
Jeanne Clark
Paula Lowell
Ian Smith

Contents

Introduction

So you want to take photographs, eh? Welcome to my world! I started taking pictures before I was tall enough to see out of the windows in my room. This is no joke. Several decades later, I'm still clicking the shutter. Photography is a passion of mine and a hobby that anyone can enjoy and grow with.

In its early days, photography was a mysterious craft, full of strange controls, black capes, and smoking flashes. But happily, those days are gone forever. Today, any child can pick up a point-and-shoot camera and take relatively good photos. Many of the cameras sold today have auto-exposure, auto-wind, auto-focus—auto-everything! As this book's title implies, any idiot can take pictures. But, we both know that you are no idiot. In fact, you must be pretty smart to have chosen this guide to the fabulous hobby of photography.

Although anyone can take photos, not everyone can take *good* ones. If you want to get past the old, wrinkled-ear snapshots that are stuck in your boxes and albums, you have to venture beyond the auto-control world. Moving up to more professional equipment and techniques can be intimidating at first! But with this book, you can relax, because each chapter will help you move up the ladder of photographic skills.

What You'll Find in this Book

In this modern age, one of the toughest parts of getting into photography is deciding what to buy and where to buy it. There is so much to choose from that it is easy to become confused. If you are not already knowledgeable of photography, you can make costly mistakes buying the wrong equipment. You'll find time-tested answers to this dilemma in the first few chapters.

You will learn about professional techniques that will make all of your photographs more enjoyable. We will explore all of the controls found on average cameras, examine composition, and talk about using light right. This is where you will acquire your shutterbug basics.

Whether you want to concentrate on capturing your kids or wildlife at the zoo on film, you'll find answers to your questions. Some of the specialties discussed include indoor photography, portraits, landscapes, and insect photography. We will cover lighting, close-ups, nature photography, and much more.

Will this book make you the next Ansel Adams or Leonard Lee Rue III? Probably not, but it can make you a very good photographer. The ideas and instructions in this text are easy to understand and use. You can put them to work right away and see results quickly. Take a moment to thumb through these pages. Scan the table of contents. I feel certain that you will agree this is your one-stop guide to the full range of photography.

Bonus Beacons

Jargon Alert
These sidebars provides the meaning of technical terms and words used in the field of photography.

Insider Tip
These boxes offer inside advice and great suggestions on how you can excel in your hobby.

Watch Out
These sidebars help you avoid trouble.

Dedication
This book is dedicated to Afton and Adam, the best children a father could ever hope for.

Acknowledgments

I would like to acknowledge and thank my parents, Maralou and Woody, for helping me buy my first camera and for being supportive parents.

My thanks to Dean Newell, Adam Woodson, Afton Woodson, and Kimberley Wallace for serving as the photogenic models in this book. Thanks also to my agent, Jake Elwell of Wieser & Wieser, Inc., and to the folks at Macmillan.

Gearing Up

In This Chapter

➤ Knowing what type of camera to buy

➤ Getting the most for your money

➤ Casual snapshots

➤ Keeping it simple

➤ High-quality photographs

➤ Putting your needs into perspective

There is a wealth of photography equipment available to you. It comes in all shapes and sizes, and for all skill levels. You can opt for a disposable camera or a lens that costs more than your car. Sorting through all the hardware options can be frustrating and confusing. Before you buy anything, be clear about what your needs are.

Having the right camera is to a photographer what having the right hammer is to a carpenter. Few carpenters would attempt to frame a house with a little tack hammer. If your goal is to take superior snapshots, you need to buy your camera from somewhere other than the cash-register rack in your local grocery store. There is no substitute for good gear when it comes to taking great pictures. This chapter will give you the nitty-gritty on the best equipment to suit your needs.

Take the Gamble Out of Buying Your Photo Gear

What do you want to take pictures of? A camera outfit that works well for taking pictures of your pets or kids may not perform well when aimed at wildlife or race cars. Knowing what you want to photograph is the first step in identifying the type of equipment you should buy.

How important will flash photography be to you? If most of your photography will rely on an electronic flash, you have to pay attention to the options in this category.

Will your subjects be moving at high speeds or will they be stationary objects? Fast-moving subjects can be captured sharply on film with a camera that has a high shutter speed. With slow shutter speeds, the image will be a blur.

Do you need a camera with a zoom lens? Many inexpensive, point-and-shoot cameras are available with built-in zoom lenses. This type of lens opens a door of opportunity for you to explore different compositions in your pictures. A zoom lens can also enable you to crop unwanted items out of a photo before a picture is taken. Give serious consideration to buying a camera that is, or can be, equipped with a zoom lens.

How idiot-proof do you want your camera to be? It's possible to buy a camera that does almost all the work for you.

Some cameras will wind your film when it is loaded, advance the film after each shot, and rewind it when the roll is finished. Many cameras will automatically set the proper film speed for you. Flash exposures are frequently automated, and you can even get auto-focus lenses. While some professionals turn up their noses at full-auto cameras, this type of system is not a bad bet for a beginner.

Sit down and make a list of what you want out of a camera. You can use the list as you move through this book to define the perfect system for you.

Keep It Simple and Get More Good Shots

Family snapshots are always one reason for buying a camera. It may be the only opportunity you get to "shoot" your in-laws legally. The best pictures are often taken on short notice and with minimal preparation. If you have to search for just the right lens, check lighting with a light meter, and set up strobe lights before you take a family photo, you may miss the golden moment. Wouldn't it be easier to grab your trusty point-and-shoot camera and capture the moment?

If your goal is to take clear, dependable pictures of your family, a mid-range, point-and-shoot camera is probably all you need.

Depending on how much you want to spend, you can get features like automatic loading and rewinding. The camera may have a built-in telephoto lens. You can count on it having a built-in electronic flash. This type of camera is small enough to fit in a jacket pocket and fast enough to use on short notice. There's a lot to be said for this type of camera. It is known to be idiot-proof.

Auto-focus cameras and point-and-shoot cameras are very popular. Auto-focus lenses actually focus on a subject from various distances. Point-and-shoot cameras can

employ auto-focus lenses, but many of them are made to focus on a range of distances. Anything within the given range will be in acceptable focus. Some professional photographers shun the automated machines, but most people love them. You don't need a sophisticated camera to capture your family on film. Simple, inexpensive cameras can give you plenty of good pictures. Spend your money on film instead of fancy hardware, and enjoy more photo sessions.

Simplicity and convenience are key elements to look for in a casual camera. Some instruction manuals are so thick that you could stand on them to get eye-level shots of giraffes. This is probably not what you want. Find a user-friendly camera that you can operate within minutes of unpacking it.

At a store where the sales staff is knowledgeable, you can get a hands-on demonstration of various types of products. This is often the most effective way to evaluate different cameras. It is also a good way to get a head start on the instruction manual. Allow someone in a camera store to demonstrate all of the functions a camera has to offer. Don't just hold the camera, look at it, and agree to buy it. Make the staff of the store earn its keep by showing you all the details of the camera.

Having someone show you, step by step, what every button is and why it is needed can be very helpful. Far too few people take the time to get complete demonstrations before making a camera purchase. Invest your time before you invest your money. You might find that the camera that looks so good is not easy to use. After handling a few cameras, you may find that one is much lighter than the rest. The more cameras you handle and investigate, the better your chances are of finding just the right one.

Watch Out

Once you buy into a specific brand, you should stick with it. This is when buying a cheap camera body and starter lens can be a big mistake. It's sort of like building a rental-car business with a fleet of Yugos.

Cameras have reached a level of development where young children can take top-notch pictures. Having an eight-year-old show you the procedures for using your new gear can be embarrassing, but it might happen. The fact that a camera is simple doesn't mean that it's not packed with features. You can find an easy-to-use camera that will fit most basic needs. Self-timers, auto-load features, auto-rewind controls, auto-focus, fill-flash units, and other time-saving features can all be had with small cameras. Heck, things are so automated now that cameras can almost take quality pictures without the help of a photographer. Chapter 2 will give you a complete run-down on most of these features. You will find additional details on photo flashes in Chapter 5.

Your Needs: When, Where, Why, Who, and What?

When

When will you be taking pictures? Are you going to be exposing film in low-light conditions, such as early morning or late evening? Wildlife and nature photographers often work in these dark conditions. Will you be using your camera during special events, such as school plays, ball games, or similar situations? If you will, you must assess

needs that are specific to your uses. For example, a built-in flash on a point-and-shoot camera may not be powerful enough to illuminate your subject at a distance. Are you dedicated enough to be out in the rain or snow with your camera? If so, you must look for equipment that is made to withstand the rigors of inclement weather.

When you take photos has an impact on the type of camera you should buy. If you are a grab-and-go photographer who responds to photo opportunities on short notice, you need a system that is lightweight and easy to use.

This could apply to parents who wish to record magic moments with their children at the most unexpected times. On the other hand, if you will be staging your shots in a studio, you can opt for more extensive equipment.

Jargon Alert

Single-Lens Reflex Camera: This is a camera in which the image entering the lens is reflected into the viewfinder. Basically, what you see is what you get with this type of camera. It is the choice of pros who shoot in the 35mm format.

Where

Where will most of your photography be done? The simple answer is either "indoors" or "outdoors." But, this is not enough of a breakdown. Let's start with indoor photography. Will your home be the primary location for your photography sessions? If so, you will be dealing with incandescent lighting that will require the use of an electronic flash or a filter to retain true colors on color film. If the camera you buy can't accept filters, this may prove to

be a problem for you. Most simple cameras don't allow the use of filters, but they overcome this obstacle by making a built-in flash available.

Indoor photography in large buildings can be too demanding for small flash equipment and short focal-length lenses.

While a pocket-size, point-and-shoot camera can do fine on a museum tour, it will not produce satisfactory results at a sports arena. The key to success with short lenses and small flashes is getting close to your subject.

Jargon Alert

Focal Length: The focal length of a lens is the distance between the center of the lens and its focal point. The focal point is a point on either side of a lens where light rays entering parallel to the axis converge. We will talk more about this in Chapter 4.

Many people like to photograph flowers and other setups in makeshift studios. If your interests run along this line, consider buying a component system that will allow you full flexibility. A fixed, on-camera flash is seldom a good choice for any type of studio photography.

Outdoor photography can be very demanding on both the photographer and the camera. There are many situations in which using your camera outside will result in disappointing images. How many times have you seen people taking pictures at the beach? Would you believe that most of these pictures will have poor and irregular exposures? They will. The bright background fools an in-camera light meter and causes subjects to be darker than

they should be. Light reflecting off of white sand or snow will fool the best in-camera meter unless a spot-metering system is employed.

A photographer who is standing in the sun and photographing a subject in the shade will get poor exposures. People feel that electronic flash is rarely needed when taking pictures with good sunlight available. Not so. Natural light often creates shadows on a subject. If the subject happens to be a person, this can result in one side of the person's face being too dark. Fill flash should be used to light a subject evenly when shadows are present. This low-powered flash removes shadows from a picture that is otherwise well-lighted. A full flash will be overpowering and create a harsh effect. If you expect to do much work outdoors, you should consider getting a flash system where you can adjust the power of the flash.

Why

Why are you taking pictures? Most people take pictures to memorialize trips and family members. If you want to go to a zoo and come back with a selection of pictures that will remind you of the animals you saw, almost any camera will get the job done. But, if you have aspirations of seeing your zoo shots on the cover of a magazine someday, you will have to invest in some serious component equipment. Getting a close-up shot of Uncle Fred and the big trout he just caught is easy. Framing the eye of a grizzly bear in your viewfinder is not so simple.

When you ask yourself why you want to take pictures, you open the door to more questions. Is your goal to have a camera around the house for when the kids do something cute, or are you looking for a hobby that you can grow with? A point-and-shoot rig is all you need for fast family photos. If you want to build a serious hobby around your passion for photography, a component system is in your future.

Who

Who will you be taking pictures of? Are your subjects going to be fast-moving children or relaxed adults? Will you be taking group photos at family reunions and similar meetings? Are you going to pin on your press pass and go in search of celebrity photos? Define who your subjects will be before you commit heavily to any type of camera system.

Fast-moving subjects require fast shutter speeds to avoid blurring. A 35mm, single-lens reflex camera is the best choice for this type of subject. (See Chapter 3 to learn more about this camera type.) Group photos often require wider-than-average lens coverage. A lens with a rating of 24mm to 35mm is a good, all-around choice. Zoom lenses that offer a range of focal lengths are also good options. Pictures that must be taken from a distance should be done with a camera that has, or can accept, a telephoto lens. Telephoto lenses that range from 100mm to 300mm are good choices, and you can buy this type of lens in a zoom configuration. (Lenses are covered in more detail in Chapter 4.)

A single-lens reflex unit uses mirrors to offer a precise view of what the lens "sees."

What

What will you take pictures of? People are a frequent subject for photographers. Any decent camera can handle the requirements of people photography. Landscapes are a popular subject with outdoor photographers. If you are into this type of work, you will need a component system with a variety of lenses. Maybe your idea of fun is crawling around in the woods in search of rare insects to photograph. If this is the case, you will want a component system that can handle macro lenses and bellows. See Chapter 12 for more information on macro lenses and bellows.

The subject matter that you will seek with your camera often dictates your needs. It's not reasonable to think that you can take quality pictures of wildlife with a pocket-size camera and lens. Neither is it rational to consider using a large-format camera to record the movements of butterflies. While a view camera works well in photographing the Grand Canyon, it's a bit clumsy to set up for home photos.

It is difficult to find one camera that works well for all needs. However, few people experience a desire to learn all aspects of photography. Once you define what you want to achieve with your camera, deciding which camera to buy will be much easier.

Here are some questions to ask yourself in order to assess your equipment needs:

Question	Yes	No
Will I be taking pictures in low-light conditions?	☐	☐
Will a small flash meet my needs?	☐	☐
Are snapshots my primary photo interests?	☐	☐
Is close-up photography important to me?	☐	☐
Will I use fill flash in outdoor pictures?	☐	☐
Do I want my photos to be of a professional quality?	☐	☐
Is a point-and-shoot camera going to suit me?	☐	☐
Should I consider a component system?	☐	☐
Are group photos something I will do?	☐	☐
Do I need a long telephoto lens?	☐	☐
Are people my main subjects?	☐	☐
Will I shoot mostly outdoors?	☐	☐
Do I need a large range from a flash?	☐	☐
Do I have a desire for serious photography?	☐	☐
Will an auto-winder be important to me?	☐	☐

Automatic Cameras

In This Chapter

➤ Putting it on autopilot

➤ What can go wrong?

➤ Frustrating flashes

➤ Extending lenses

Do you want a camera that will do all the work for you? Are you looking to spend less than $200 on a camera? Have you been curious about pocket cameras that preach the point-and-shoot principle? If so, you're in the right chapter. The camera equipment discussed here is simple, inexpensive, easy to use, and can produce terrific photographs. As you read this chapter, you will learn all about point-and-shoot cameras and where they work best. You will also be introduced to onboard flash units and zoom

lenses that are built right into cameras. In short, this
chapter will tell you all you need to know to assess your
interest in a simple camera.

Auto-Load, Auto-Wind, Auto-Everything

Modern cameras are being made to do everything on their
own. With a self-timer, a camera can even decide when
it's the right moment to freeze time on a frame of film.
Today's cameras are incredibly smart. There has never
been a time when getting into photography was so easy—
that is, assuming you can figure out what all the buttons,
knobs, and levers on a new auto-everything camera do.

In some ways, older cameras were less frustrating to work
with. New automatic cameras can be a challenge for any-
one to figure out. It's kind of like setting the clock on your
VCR. If you take the time to learn the steps involved with
the process, it's not difficult. Automatic cameras can be
intimidating at first, but they are a joy to use once you
have mastered the controls.

The amount of automation found in a pocket camera
varies from manufacturer to manufacturer. Price is also
a factor in the number of automatic functions a camera
performs. I think automatic cameras are like computers;
they're fantastic when they work properly, but a pain in
the neck when they don't.

How simple are today's point-and-shoot rigs? Very simple.

Many point-and-shoot cameras are equipped with a fixed-
focal-length lens in the 35mm range. This is a fine choice.
A 50mm lens is considered a standard lens. Basically, this
means that a 50mm lens sees images with a likeness simi-
lar to what the human eye sees. A lens with a longer focal
length, such as an 85mm lens, is a telephoto lens. A
35mm lens is a mild wide-angle lens. Using a 24mm lens
is good for landscape photography, but not for portraits. A

lens in the 35mm to 70mm range, especially if it is a zoom, should serve you well. Consult Chapter 4 for more details on lenses.

We've been talking about 35mm equipment up to this point. If you want to do much quality photography, a 35mm camera is an excellent choice.

Here is an example of a very inexpensive automatic camera.

You might be tempted by the super low price of a 110 camera, but avoid this temptation. The quality of pictures taken with 110 and 126 cameras can't compare with those

made with a 35mm camera. A camera with a 110 format produces negatives that are about one-quarter the size of a 35mm negative. This results in images that are not sharp and that will not enlarge well. Many flaws will be noticeable if 110 film is enlarged. Cameras with a 126 format use drop-in film cartridges, as do 110 cameras. The cartridges do not allow for proper film placement, so picture quality is often poor. It's not a bad idea to introduce a young child to photography with either a 110 or 126 camera, but that is about the only good reason I can think of for buying one. Even if you are looking for something at the bottom rung of the photography ladder as a starting point, don't go smaller than 35mm.

What Could Possibly Go Wrong?

If you think that nothing can go wrong with auto-everything cameras, you're wrong. A lot of mishaps can occur with any automatic camera. While most pocket cameras are simple to operate, they can produce some annoying problems for the people who use them. Let me explain.

Watch Out

Many photographers using direct-vision automatic cameras obstruct their lenses accidentally with a finger or strap without knowing it until their film is processed.

Since the viewfinder on this type of camera is offset from the lens, you can't see if your camera strap or finger is in part of your picture.

Is the Film Wound Correctly?

Many modern cameras wind film on their spools automatically. This is fine when all goes well, but sometimes the film leader is not picked up in the winding process. You could be shooting blanks each time you snap the shutter. Make sure your film does, in fact, load.

Battery Failure Foils Your Fun

One of the most frequent problems with an automatic camera is not the camera's fault. It is a dead or dying battery. Get a spare battery for your camera and, like the credit card company says, "Never leave home without it!"

Red Eyes Ruin Flash Pictures

You've probably seen the handiwork of the red-eye monster in photos.

Jargon Alert

Red Eye: This is when the eyes of a subject are red in a photograph. The problem is caused by having a flash that is too close to your lens. It is a common problem with point-and-shoot cameras. This evil creature lives in the flash unit of many cameras. You can reduce the red-eye effect with a red-eye reduction system and a pop-up flash, and by increasing the light where your photo is being taken.

Understanding Your Field of Focus

Cameras may also have problems with focusing if they employ auto-focus. There is a difference between point-and-shoot cameras and auto-focus cameras. Point-and-shoot cameras have a set range in which objects appear to

be in focus. Auto-focus lenses adjust their focus based on the location of a subject. As good as auto-focus lenses are, they can be fooled. As an example, if you were to take a family portrait using a self-timer, you might find that part of your family was soft in terms of focus. If you are all standing side by side, the auto-focus should work well. But, if some of the family is in front of the rest of the family, the auto-focus is likely to lock in on only some of the subjects. This results in a picture with some distortion in it.

Shade Your Lens in Bright Sunlight

Sun flare can be a nasty problem when using a pocket camera. You can overcome this by shielding the lens of your camera from the sun with your hand. But if you're not careful, your hand will wind up in the picture. Since lens shades won't work on flat-faced cameras, you have to protect the lens by some other means. The human hand is usually the most effective. If you don't prevent stray light from shining on your lens, you will see bright spots that resemble stars or doughnuts on your finished prints.

Automatic Flashes Aren't Foolproof

Automatic, built-in flashes sound good on paper and in advertisements, but they can limit your creativity. They can also fail to meet their minimum requirements. The sensors that trigger an automatic flash can be fooled by light patterns.

The Flaws of Built-In Flashes

For the money you spend and the purposes intended, pocket cameras with built-in flashes are a good bargain, and they do a good job. Don't expect this type of camera to provide you with professional-grade photos on a consistent basis. It won't happen. You should expect some problems with these types of cameras, so shoot more than

one shot of each scene. This is good advice for any photographer with any type of equipment. Switch positions and take several shots of special scenes. Leave as little as possible to chance. Built-in flashes are both practical and convenient. You don't have to worry about mounting brackets or dangling cords getting in your way. Since built-in flashes are with your camera at all times, you are always prepared for low-light shooting. There are, unfortunately, some flaws associated with integral flash units.

Most pocket cameras are made with built-in flash units. This does not mean, however, that the flash will be adequate under all circumstances. You can only expect so much from a tiny flash unit. I mean, would you use a toothpick as a bat in a Major League baseball game? I've known a number of rookie photographers who have been devastated that their flash pictures didn't turn out well when using small, onboard flash units. The types of problems vary, but they continue to turn up.

Harsh lighting can be a problem with onboard flash units. Flashes that you do not have exposure control over, such as most of the flashes on inexpensive cameras, can produce hotspots. Since the power of the flash cannot be adjusted manually, you may experience overexposure in your flash pictures. Taking a picture of your child on Santa's knee may leave you with glaring reflections in Santa's glasses. Uncle Ed's balding forehead may bounce the flash right back at your lens, creating a hotspot.

Jargon Alert

Hotspot: This is a concentration of light in one particular area of an image.

Again, if the flash cannot be moved or controlled, you are bound to deal with some problems. Convenience doesn't come without its cost.

The first time you take a pocket camera with a built-in flash to an event and attempt to take a picture at some distance, you will probably see just how inadequate the flash is. You have to be up close to get good results with tiny flash units. Professional flash units can reach out for 60 feet or more, but don't expect more than a few, say about 10, feet of effectiveness from a built-in flash.

Depth is not the only concern with small flash units. The width of coverage with these little lighting devices can also lead to disappointment. While professional flash units can be fitted with accessories for normal, wide-angle, or telephoto use, integral flashes don't enjoy this flexibility. You may find that the edges of your pictures are too dark when you operate in a wide-angle mode. This is a problem known as vignetting.

Jargon Alert

Vignetting: This is a condition where the edges of a picture are dark. It is often caused by using a flash that emits a beam of light that is too narrow for the lens being used. It can also be caused by a lens hood on a wide-angle lens. This is usually not a problem with simple, point-and-shoot cameras. The flash units on these cameras are designed to work with the lens on the camera. However, when you are working with an interchangeable lens system, where you might go from standard to telephoto to wide-angle lenses, the problem can manifest.

When you buy a camera that has automatic film advancement, you expect to be able to shoot pictures as fast as you can pop the shutter. Well, you can, but don't count on your flash keeping up with you. The recycling times for flash units vary. This is true of even very expensive models. If you try to shoot flash pictures in rapid succession, you may find that your flash can't keep up with your auto-winder. This, however, is something that you can test in a store before you buy a camera.

To test the recycling time of a flash, load batteries into the flash and the camera it will be used with. Turn the flash on. When the ready-light glows, push the shutter button on the camera. If the flash doesn't fire every time the shutter clicks, you know that the flash can't keep up with the auto-winder. (By the way, film is not needed for this test.)

You can't angle or bounce light from a typical built-in flash unit. All of your lighting is coming at a subject head on. This is rarely flattering in portraits. While a built-in flash can provide good lighting for a technical reproduction of a scene, it does not offer the creative options that other types of flash units do.

Integral Extending Lenses

When you buy a pocket camera, you have several options on the type of lens your unit will use. Inexpensive models will have one fixed focal length. A 35mm lens is common on pocket cameras. This is a borderline wide-angle lens. It's good for getting a lot in a picture, but it's not suitable for taking shots of subjects that are some distance away.

A normal lens is generally considered to be a 50mm lens. This lens is supposed to see subjects in the same way that a human eye does. Anything smaller than a 50mm lens is heading into the wide-angle category. When the lens size

gets very small, you're into fisheye lenses. Lenses with focal lengths greater than 50mm are working toward telephoto ratings. See Chapter 4 for more details on lenses.

Many pocket cameras offer zoom lenses of one sort or another. This type of lens is a good investment. It gives you much more control over your pictures. A good, all-around zoom lens is one that has a range of 35mm to 70mm. For average photography, you would not want a lens with a rating smaller than 35mm. Zoom lenses with wide ranges offer the most versatility.

Keep in mind that the built-in flash on a pocket camera may not offer enough power to light a subject properly when a telephoto setting is used on the lens. This is not always the case, but it is something that you should investigate. You can find details in most instruction manuals that will specify the limits of a flash unit.

If you buy a camera with a lens that can go from 35mm to 70mm, you're in good shape. This range of focal lengths is adequate for average photo situations. It is not suitable for wildlife work, but it will cover everything from people to landscapes, with some other subject matter thrown in for good measure. A 35mm lens gives you good landscape potential. Lenses that are rated at 85mm perform very well with people. Longer lenses can be used for subjects that are not as accessible. Getting a camera with zoom capabilities is in your best interest.

Component Systems

You don't have to be a professional photographer to benefit from a component system. But, if you want to become a pro, or even a semi-pro, you have to go this route. What is a component system? It is a group of photography equipment that makes up a viable tool for handling a variety of photographic situations. At the least, it is a camera body and some interchangeable lenses. It can include independent light meters, filters, flash units, and much more. When you get into component systems, you are stepping up in price, but you can build these systems over time without breaking your bank account. If you are truly serious about taking fantastic photos, this is the only way to go.

The first element of a component system is a camera body. This is the heart of a system. It is what holds your film and allows you to make many exposure settings. Lenses are the second important piece of the puzzle. There are lenses for all occasions, and you will learn more about them in the next chapter. As you continue to fill out a component system, you will probably want an electronic flash. See Chapter 5 for advice on these items. The more advanced you become, the more you will want. An independent light meter is sure to be on the wish list of a serious photographer. The extent to which you can go to in building a system is nearly unlimited. In this chapter, we are going to talk about format sizes, brand-name equipment you can depend on, used cameras, and automatic film-advancers.

Picking a Brand Name that You Can Stick with

When you choose a particular brand of camera to build a component system around, you must be judicious. Once you start with a brand, you should stick with it. There are many brands of cameras available that will give you professional-quality photos. Some brands offer more lenses and accessories than others do. This is important to a person who is building an extensive system.

When I think of professional 35mm equipment, two brand names come to mind: Nikon and Canon. Other manufacturers of 35mm equipment get some professional attention, but there are clearly two, or maybe three, leaders. In medium-format equipment, one name is king, while others are also respected. You don't have to buy into the best-known brands to get good service and quality, but it doesn't hurt. The important thing is to pick a brand that you can grow with.

How will you know what brand of camera to work with? Many factors may play a role in your decision. The amount of money you are willing to spend for various types of equipment is one consideration. Top-notch names command big prices. You can go with a lesser-known name and get good quality for a lower price. But make sure that your budget-minded purchase has enough lenses and accessories available to keep life interesting as your skills and interests grow.

My first 35mm camera was a Minolta. It was a good camera that gave me thousands of wonderful pictures. This brand is respected among professionals, and it offers a wide variety of options for building a component system. When I grew into a new level of photography, I switched to Canon equipment, which I still use today. I love it! Canon is a major contender in the professional market. Over the years, I've spent well over $10,000 to develop my system. Nikon is known for its reputation among professionals. The name is almost synonymous with professional. Any of these brands will provide you with more options than most people can afford to buy. And, there are other good brands, like Olympus, to choose high-quality products from.

Before you buy a camera body, do some research. Look at a listing of what accessories are available within the brand. Check prices on the various brands. If you can see that there is a depth of support accessories and that you are comfortable with the price ranges, you're well on your way to picking a brand. Handle various cameras and operate them in the camera store. Have someone at the store run through all of the controls with you. When you buy your first camera body, you set the tone for your entire system. Don't buy until you are sure that you like the brand.

Generic lenses can be used on most camera bodies, but this is somewhat self-defeating. Why pay a small fortune for a professional camera body and then attach a dime-store lens to it? This doesn't make sense. Your lenses have a tremendous impact on the quality of your photographs. Try to keep all of your purchases within the same brand. This will normally produce the best results. (We'll talk more about lenses in Chapter 4.)

Top-notch lenses made by camera manufacturers will usually fit only one brand of camera. For example, a Canon lens will not work on a Nikon camera. This being the case, you must venture into lesser-known names to get supplemental lenses that are not made by the manufacturer of your camera body. Many accessory lenses can produce good photos, but your best images will probably come from lenses made by your camera manufacturer.

If you're looking for a medium- or large-format camera, you can't go wrong with a Hasselblad. This name is well-known among professional photographers. Mamiya is a good brand to get into, and so is Bronica. To buy these types of cameras, you need deep pockets that are filled with money. Most casual photographers don't need to go to this expense to obtain fulfillment from their hobby. However, if you want to, any of these brands will serve you well, and brands like Pentax can also meet your needs. We'll be talking about medium- and large-format cameras later in this chapter.

The durability and smooth functioning of big-name cameras are primary reasons why they are so expensive. Also, the lens elements (pieces of curved glass that refract light and funnel it to a destination) in lenses, as well as their coatings, contribute to higher prices.

Professionals who run dozens of rolls of film through their cameras on a daily basis can't get by with a consumer-grade camera, but you can.

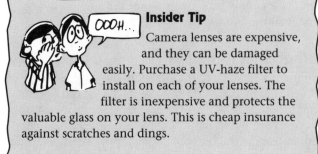

Insider Tip

Camera lenses are expensive, and they can be damaged easily. Purchase a UV-haze filter to install on each of your lenses. The filter is inexpensive and protects the valuable glass on your lens. This is cheap insurance against scratches and dings.

Buying a Used Camera Is a Wise Way to Move into Photography

Buying used camera equipment makes a lot of sense when you are entering the hobby. Not only will your out-of-pocket expense be considerably less, you will also get to experiment with equipment that you can resell if you find you don't like it. Sure, you can sell new stuff too, but you will lose a lot of money in the process. Camera gear depreciates rapidly in most cases, so buying used equipment allows you to take advantage of the price drop instead of being nailed by it.

Used equipment provides an economical and sensible way to enter the field of photography, but make sure that what you are buying is in good working order. When you inspect used equipment, always put the equipment through a full operation. In other words, cock the shutter and push the shutter button. Do you hear the shutter click? Watch to see the shutter move. If the camera has a removable lens, remove it. Depending on the type of equipment you are buying, the test methods will vary. Basically, do everything with the equipment that it is intended to do and see if it seems to work properly. Well-made photo gear can easily last for decades, so don't be frightened off by older

stuff. A lot of my equipment is pushing 20 years in age, and it all works flawlessly.

What Should I Buy?

Knowing what type of equipment to buy is something that comes naturally to some people. But, it can be difficult for others. There are various camera formats available to you. Each has its place. Some are more versatile than others. For general-purpose photography, a 35mm format is best. Medium-format cameras are good for taking pictures that will be enlarged. Large-format equipment is suited to landscapes. To get more specific on this subject, let's look at the various formats individually.

35mm, the Choice of Champions

The most versatile type of camera that you can buy is a 35mm format.

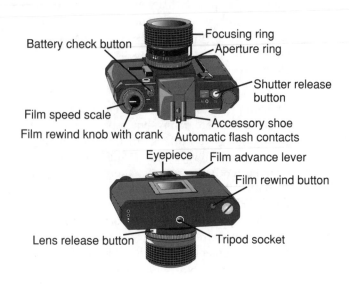

A direct-view 35mm camera is an excellent choice for a beginner.

You can do almost anything with this type of rig. Large- and medium-format cameras have certain advantages over 35mm units, but the handy 35mm is by far the more popular. This popularity is well founded.

A quality 35mm single-lens reflex camera can be outfitted with lenses that range from fisheye to super telephoto.

> ### Jargon Alert
> **Fisheye Lens:** This is a lens where barrel distortion is sacrificed to obtain an angle of view of up to 220 degrees. In lay-person terms, it is a lens that gives you an almost round perspective of the world around you. Fisheye lenses are not very practical, but they can be fun to work with for special effects.

You can install macro lenses, bellows, auto-winders, high-powered electronic flashes, and other accessories. The next two chapters will help you to identify and under-stand lenses and flashes. With the camera set up properly, you can photograph any subject successfully. You can even mount a 35mm camera on a microscope or telescope for exciting and unusual pictures.

What makes the 35mm system so desirable? It is light-weight and easy to use. The cost of 35mm equipment is much less than that of larger formats. You can equip a 35mm camera body with a wide-range zoom lens and meet most of your photo needs without ever changing lenses. Many zoom lenses incorporate a close-up feature in the lens so that you can shoot anything from insects to airplanes with the same lens. Film for the 35mm format is readily available in all areas and is not too expensive.

Processing for the film is also easy to arrange. All things considered, it's no wonder why the 35mm format is a favorite.

If you want to get serious about photography and build a component system, the 35mm format will most likely be the best choice. As long as you buy into a major brand name, you will find a seemingly endless supply of accessories to add to your collection. Gee, I wonder if manufacturers planned it this way? Here are some of the goodies you might buy:

➤ Camera body

➤ Interchangeable, fixed-focal-length lenses

➤ Interchangeable zoom lenses

➤ Lens filters

➤ Electronic flash

➤ Independent light meter

➤ Macro lens

➤ Camera supports

Camera supports you can use include:

1. Tripods—Ideal support under most circumstances.

2. Monopods—Light, easy to carry and use, offer good support.

3. Tabletop Tripods—Good in a studio and handy for macro nature photography.

4. Support Sacks—Cheap, easy to make, lightweight, and good support when shooting from a car window.

5. C-Clamps—Ideal support when shooting from a car window, also good whenever there is a flat surface available to clamp to.

6. Gun Grips—Not extremely stable, but better than basic handheld photography.

7. Shoulder Pods—Perfect for long lenses when shooting wildlife or sports photos.

Of course, you don't have to buy everything at once, and you don't even need everything on this list. A camera body and lens are all you need—except for film—to get started. Build your system slowly, as your interests and needs define themselves.

A name-brand setup, like the one mentioned above, will cost between $300 and $500, depending on the brand and features you choose. This is not a lot to pay for all the features and flexibility you will get. Remember, the camera body is the foundation of your system. The body you buy will play an important role in the development of your overall system. Once you know what you want to do and which brand you prefer, buy the best body you can. Cutting corners on the camera body will hamper your growth as a photographer.

Large-Format and Medium-Format Cameras Can Cost a Fortune

Don't even think about buying into a medium- or large-format system unless you have thousands of dollars to spend. You can expect to spend in the neighborhood of $2,500, at mail-order discount prices, for a starter unit in a medium-format camera. One camera body that I checked pricing on was nearly $6,500—just for the body! Few photographers can afford this type of equipment unless they are making their living with it.

What's the big deal about medium- and large-format cameras? Medium-format cameras are used extensively in studio photo sessions. They are also used by professionals for weddings, commercial photography, portraits, and similar

types of shoots. One of their main advantages is the fact that they produce a larger negative than a 35mm system does. The larger negative enables darkroom technicians to perfect a picture so that it is nearly flawless. Since 35mm negatives are smaller, they are harder to work with in a darkroom. Enlargements lose some sharpness when they are made. This is less apparent with medium- and large-format negatives.

There is often some confusion over various photo formats. If you're feeling a little uneasy in your understanding of what all this format stuff means, relax. Let me put the facts into plain English for you.

A medium-format camera is one where the photographer normally looks down into a viewfinder on the top of the camera. This type of camera is also called a roll-film camera. The film used in a medium-format camera produces a negative that is anywhere from three to five times larger than negatives made with a 35mm system. This larger negative allows for higher-quality enlargements and more creative darkroom work, such as airbrushing out blemishes or adding color.

Very few amateur photographers use medium- or large-format equipment. Film and processing are more expensive than they are for a 35mm format. The cost of equipment is considerably more, and an average person doesn't need the professional edge that larger negatives give.

Large-format cameras can produce negatives that are a full 8" × 10" in size. Think about this. The negative is the same size as many photo enlargements. As you might have guessed, this large negative can produce some impressive enlargements. Landscape work is the most common subject for large-format cameras, but they are also used in commercial advertising photography.

Large-format cameras are used by landscape photographers who are very serious about what they do. These cameras often sell for several thousand dollars. Unless you have money to burn and a dedicated interest in landscape and technical photography, you don't need a large-format camera. You can have more fun with a 35mm camera and save a lot of money in the process.

Those Lovable Lenses

In This Chapter

➤ Landscape lenses

➤ Normal lenses

➤ Long-shot lenses

➤ Close-up lenses

➤ Big-image bellows

➤ Specialty lenses

➤ Funny fisheyes

The lenses you use with your camera are critical components of your photography system. Cheap lenses are never a bargain. Inexpensive lenses produce inferior pictures. You don't have to pay thousands of dollars to get good pictures, but don't expect much from a $49.95 lens that you buy at some sale. Photography is not an inexpensive hobby. If you want to play, you have to pay.

In this chapter, you are going to be introduced to a variety of lenses. Some of them are essential; others are expensive toys that you won't often use. We will talk about wide-angle lenses, normal lenses, mirror lenses, telephoto lenses, anti-distortion lenses, zoom lenses, macro lenses, bellows, tilt-and-shift lenses, and fisheye lenses. Yes, I said fisheye, but don't worry, you won't need scuba gear.

What exactly is a lens? Think of it as the eye of your camera. Even better, imagine it as a magnifying glass that allows you to make a variety of images on film. Lenses often contain several pieces of precision glass. These are necessary to correct visual distortion. When you focus a lens, you are making adjustments for distance. This is the key to a sharp picture. This distance is referred to as focal length. Depending on the focal length of a lens, you will get different images. As you move through this chapter, you should start to understand the meaning of focal length and lens selection better.

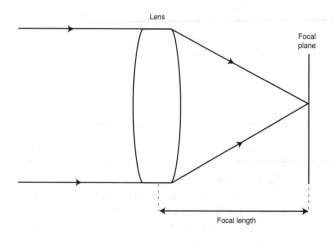

The lens converges light to a point of sharp focus. The distance from the lens to the focus point (focal plane) is the focal length.

Lenses are rated by focal length. This is measured in millimeters. The smaller the rating is, the wider the view is through a lens. For example, a 16mm lens has a much broader view than a 50mm lens. When you drop down to fisheye status, your pictures are going to have a round perspective. They will no longer look like typical photos. You can use this creative aspect to your advantage.

Lens Types and Their Focal Lengths

Lens Type	Focal Lengths Available	Closest Focusing Distance (in feet)	Angles of View Available
Fisheye	7.5mm to 15mm	0.7	180°
Super Wide-Angle	14mm to 20mm	0.9	94° to 114°
Wide-Angle	24mm to 35mm	1 to 1.25	63° to 84°
Standard	50mm	1.75 to 2	46°
Telephoto	85mm to 300mm	3 to 10	8° to 28°
Super Telephoto	400mm to 800mm	15 to 45	3° to 6°

Wide-Angle Lenses

Wide-angle lenses are very useful for a number of photo situations. If you enjoy taking scenic pictures, a 24mm lens is an excellent choice. This lens will allow a great deal of coverage in your pictures. Unlike a fisheye lens, a

wide-angle lens produces pictures that are basically normal. Perspective can be lost in super wide-angle shots, but the general effect is pleasing.

Jargon Alert

UV-Haze Filter: This filter absorbs ultraviolet light. It cuts down on haze in long shots, such as landscapes, and gives a sharper image with better color saturation. It also serves as protection for your costly front lens element.

A 24mm lens is about as much of a wide-angle lens as you can use without experiencing distracting distortion. It is my favorite wide-angle lens, but some people prefer a 28mm lens. You won't capture as much of a scene with a 28mm, but distortion will be less than what is experienced with a 24mm lens. Many photographers opt for a 35mm lens to meet their wide-angle needs. This is a useful lens, and it's not a bad compromise, but it can't include nearly what a 24mm lens can.

A So-Called Normal Lens that Is Rarely Used

A 50mm lens is considered normal. This lens is supposed to depict the world in the same perspective as the human eye sees it, photographically speaking. There are very few occasions when a 50mm lens is the ideal one to use. Its focal length is too long for wide-angle work and too short for telephoto work.

Mirror Lenses Can Leave Round Spots on Your Images

Many photographers dream of owning a powerful telephoto lens. These lenses tend to be very expensive, and they can be as large as an elephant's leg. One cost-effective alternative to a traditional telephoto lens is a mirror lens. A mirror lens is usually short with a large diameter. Photographers pay a price when they buy a relatively inexpensive mirror lens. The first concession is accepting the fact that a lot of light is needed to utilize the lens. A typical aperture is f-8. (See Chapter 6 for more advice on creative uses of aperture settings.) In addition to needing a lot of light, mirror lenses are notorious for creating doughnuts, or round spots, on finished photographs.

The big selling point of mirror lenses has always been their price. You can buy a 500mm, f-8 mirror lens for a mere fraction of what a 500mm normal telephoto lens would cost. If you are looking for perfection in your photographs, you won't get it with a mirror lens.

What makes a mirror lens so different from a typical telephoto lens? Mirror lenses are short and light. They use mirrors to fold light in a way that regular telephoto lenses can't. There are trade-offs for this advantage. As an advantage, mirror lenses with long focal lengths have an ability to focus on items close at hand. The downside is that the aperture is fixed. It cannot be adjusted like a typical lens. A variable diaphragm, such as the type found in common telephoto lenses, can't be incorporated into a mirror lens. If it were installed, it would cause vignetting. The only exposure control is in the form of film and shutter speed. While mirror lenses offer some advantages, you must weigh the limitations that they place upon you.

Super Telephoto Lenses that Can Cost More than Your Car

Can you imagine spending more for a lens than what some people pay for a car? Well, there are lenses with price tags that do compete with cars. The last time I looked, a 600mm, 4.0 lens for my brand of camera was selling for more than $9,000. A 300mm, 2.8 lens was going for about $4,600. In either case, the price of these lenses is steep, and some lenses cost considerably more.

Built-in hood

Distance scale

Focusing ring

Depth-of-field scale

This telephoto lens is fit for a real pro.

A Working Combination

To establish a working combination in a good photograph, you must consider aperture, shutter speed, and film speed. An aperture is a circular hole, in or near a lens, that controls the amount of light reaching film in a camera. Aperture also controls the depth of field experienced in a photograph. Shutter speed refers to the amount of time

that a shutter remains open during a photographic exposure. Film speed is a measurement of a film's sensitivity to light.

Insider Tip
Don't use a film with a speed higher than ASA 200 if you want to have enlargements made from your negative or slide. The more a negative is enlarged, the more grain will stand out in film. Faster films, like an ASA-400 film, become very grainy when enlarged.

These three elements combine to make a proper exposure. A lens that has a slow aperture, one with a large number at the bottom of the scale, requires the use of a slow shutter speed or a fast film. In some cases, it requires both. For optimum results, you should be able to use a slow film speed, something in the neighborhood of ASA 100, with an average shutter speed of at least 1/125th of a second. (American Standards Association [ASA] is a rating assigned to film based on the sensitivity of the film. It is a benchmark of a film's speed.) If lighting is poor, then you need a fast lens, one that has a small number at the end of its aperture scale.

Aperture is figured in f-stops. An f-stop of 5.6 is about average for a typical telephoto lens. A faster lens, one with an open aperture of f-2.8, will cost more. Slower lenses, such as mirror lenses, that have apertures of f-8 are less expensive. You have to match your shutter speed, film speed, and aperture to your applications. We will talk more about this in Chapter 6.

If you need a lens that will allow fast shutter speeds in low-light conditions, you have to pay handsomely for it. Why would you need a fast aperture? If you were a sports photographer, your subjects would be moving quickly. To capture them on film without having their images blur due to motion, you need a fast shutter speed. On a bright, sunny day, this would not be a problem with most lenses. However, a cloudy day could render a lens with a slow aperture useless. If you make your living taking fast-moving or low-light pictures, you have to be prepared to pay steep prices for your equipment.

If you're not a working pro, you can compensate for a slower aperture by loading a faster film. Why can't the pros do this? Fast films produce grainier pictures than slow films. Many publishers want original slides that have been shot at a slow film speed, like ISO 64. (International Standards Organization [ISO] is another rating of film speed. ASA and ISO numbers are the same in terms of film speed.) A pro using 400-speed film might not be able to sell the images. If your goal is to have good slides or modest enlargements, a faster film will work fine. Film with an ISO of 200 is a good middle-range film for most amateur photographers.

Anti-Distortion Lenses at Extortion Prices

Anti-distortion lenses, lenses with special coatings on the glass, are very expensive. The coating does improve image quality, but few amateur photographers need it. A 300mm, 4.0 lens for my camera is sold by a major dealer for just under $650. If the lens is coated and classified as an "L" lens, the price jumps to almost $1,450. Paying more than twice as much to get the better quality lens is usually hard to justify.

Insider Tip

OOOH...

Unwanted sunbursts on your prints and slides are the result of sun flare. A lens hood can reduce the occasions when unwanted sun ruins what would have been a great picture.

Zoom Lenses: Can One Lens Do It All?

Manufacturers of zoom lenses would like you to believe that their wonder lenses can do it all. Can they? No, but they can come close. Zoom lenses are an excellent choice for photographers on a budget and for photographers who have not yet determined their exact needs. Many professional photographers have independent lenses in various focal lengths instead of zoom lenses. This is because zoom lenses are said to lose some quality in photographs when compared with fixed-focal-length lenses. If you buy a quality zoom lens, I doubt you will be able to tell the difference between pictures taken with it and those taken with a fixed lens.

Macro Lenses Make Mountains Out of Molehills

If you like the idea of taking pictures of insects and other small objects, you should invest in a macro lens. Close-focusing lenses let you get pictures of small objects, but they can't compare with a macro lens. Many photographers use close-up filter attachments for occasional close-up work. However, if you plan to spend much of your time taking aim at little creatures, buy a macro lens.

When a macro lens is coupled with the extension tube
that is usually supplied with the lens, you can get incred-
ible close-up photos. Tiny items will appear life-size on
your film. You can photograph a watermelon seed and
make a work of art out of it. Ever want a picture of the eye
structure of a house fly? You can get it when you shoot
with a powerful macro lens.

Macro lenses are designed to focus in extremely close-up
situations. A coma, or aberration, is less likely to occur in
close-up work when a true macro lens is used. In addition,
a macro lens can also be used as a regular lens. If you have
a 50mm macro lens, you don't need a standard 50mm
lens. A 100mm macro lens is, in my opinion, the ideal
one to choose. This one lens gives you a close-up lens,
a portrait lens, and a short telephoto lens all in one
package.

A bellows can be used with a macro lens for extreme close-ups.

If Big Is Better, Bellows Are Great

When you want to really get serious with close-up photography, buy a bellows to work with your macro lens. The head of a straight pin can be enlarged to a point where it commands attention on film when a bellows is used. A bellows is a collapsible contraption that fits on a camera between the camera body and lens. Turning a knob on the side of the bellows will extend or compress the bellows material. Tiny objects can be magnified several times their true size with the use of a bellows and a macro lens.

A bellows is not the type of equipment most photographers pack in their camera bags and vests. However, if you enjoy photographing small, stationary objects, a bellows is a good investment. Due to the high magnification and minimal field of focus experienced when using a bellows, your subject must remain still. Even a light wind will make it extremely difficult to capture the inner beauty of a wildflower or strand of wheat.

Tilt-and-Shift Lenses Can Make a Crooked Building Straight Again

Perspective is often difficult to maintain in architectural photography. Have you ever studied a picture of a city and noticed that the buildings seem to be leaning backwards? This is a common problem when shooting architecture with a standard lens. Tilt-and-shift lenses solve this problem by allowing you to shift the lens and maintain a vertical perspective on the buildings. Few photographers have enough need for this type of lens to justify its rather expensive purchase. However, if you plan to work extensively with tall objects, such as buildings, sculptures, and so forth, a tilt-and-shift lens could benefit you.

Fun with Fisheyes

Fisheye lenses can be fun to work with. They allow you to create great special effects. However, they don't have many practical purposes. Of all the lenses available to you, fisheye lenses are one of the least important.

Some Key Factors in Choosing Lenses

Some key factors to consider when buying a lens should be committed to memory.

➤ Buy a lens that is made by the manufacturer of your camera whenever possible.

➤ Make sure that the lens has an aperture rating that suits you.

➤ Will the lens accept screw-in filters, and what size does it require? Buy a UV-haze filter when you buy the lens and install it right away to protect the actual lens.

➤ Does the lens have a retractable lens hood to block sun flare? Can you install a rubber lens hood yourself? Be advised: wide-angle lenses, like a 24mm lens, often will not allow the use of a lens hood. If a hood is used, it shows up in the picture by blacking out the corners.

➤ Make sure that the lens you are buying will mount on and work with your camera.

If you follow these guidelines, your lens purchase should be relatively painless.

Chapter 5

Electronic Lighting

In This Chapter

➤ Independent flash units

➤ Stopping time with strobe lights

➤ Seeing shadows before you shoot

➤ Taking your show on the road

➤ Flash accessories

Artificial lighting solutions for modern photographers have never been so good. Many new cameras have built-in flashes, but that is only the tip of the iceberg when it comes to electronic flashes and studio lighting. Most photographs live and die by their lighting and composition, so lighting is a critical concern for serious photographers.

No More Powder and Smoke

You've probably seen old movies where a photographer took a picture with a flash that exploded to create the light, leaving smoke and powder in its wake. There is no powder and smoke associated with today's flash photography. Light is generated from batteries and electricity, which are cool, non-explosive materials that are more dependable and easier to use than the flash powder of days gone by.

You can buy a portable, electronic flash for less than $25.

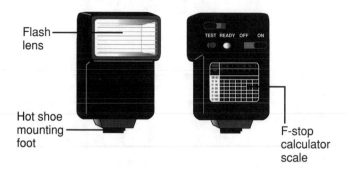

Flash lens

Hot shoe mounting foot

F-stop calculator scale

An inexpensive flash requires manual exposure settings.

Better models, with more features, stretch the price up to around $70. Big, long-range, pro-quality units get much more expensive, but you probably don't need anything so fancy.

When you shop for a flash, there are a few features that you may want to look for. Will the flash accept color filters? Does the flash head tilt and/or swivel? Experienced photographers know that bouncing light from walls, ceilings, and reflector cards will produce even, soft lighting that is pleasing to the eye. Some inexpensive flash models offer both a tilt and swivel feature. What is the recycling time for the flash?

Knowing the coverage area of a flash can be quite impor-
tant. If you are using a wide-angle lens with a flash that
doesn't offer wide-angle coverage, your photos are not go-
ing to be satisfactory. The same holds true if you are using
a standard flash with a telephoto lens. Ask your camera
dealer to explain the various ranges of any flash you are
considering buying.

If you are buying a high-quality flash, it should be capable
of handling standard, wide-angle, and telephoto photog-
raphy. Adapters are normally placed over the standard
flash head to either concentrate the beam of light for tele-
photo shots or to disperse it for wide-angle work.

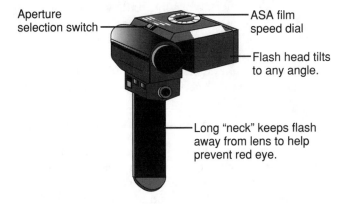

Aperture selection switch

ASA film speed dial

Flash head tilts to any angle.

Long "neck" keeps flash away from lens to help prevent red eye.

This high-quality flash unit is suitable for a professional.

Many photographers use two independent flashes, one on
each side of the lens, to produce even, shadowless light-
ing. This type of lighting is very popular. If you decide to
buy two flashes to work together, make sure that they are
compatible with one another. A little peanut slave (a re-
mote firing device shaped like a peanut) can be installed

on one of the flashes so that both flashes fire simultaneously. Slaves like this can be bought for less than $20. Brackets are made to accept two flashes at one time; this type of arrangement provides high-quality lighting, even when low-powered flashes are used.

One other consideration to keep in mind is whether the flash units work with a hot-shoe attachment or a sync cord.

Jargon Alert

Hot Shoe: A hot shoe is a fitting on a camera, generally positioned over the viewfinder, that accepts the mounting of a flash and is electronically in sync with the camera to fire the attached flash on demand. When a hot shoe is present, a PC cord or sync cord is not needed to connect the firing mechanism of the flash to the camera.

Your camera may not have a hot shoe. If it does have one, it will be on top of the camera. Some cameras have flash holders that are not hot shoes. Take your camera with you when you shop for a flash. Mount the flash and see if it fires when you press the shutter button. If it doesn't, either your camera or the flash unit isn't hot-shoe equipped.

Flashes that don't link automatically with a camera through a hot shoe require the use of a sync cord. This is simply a cord that runs from a port on the flash to a port on the camera. Sync cords usually work fine, but they do get in the way sometimes.

Studio Strobes: Faster than a Speeding Bullet

When I say that studio strobe flashes are faster than a speeding bullet, I mean it. This type of lighting system, combined with a camera that offers a fast shutter speed, can literally stop a bullet in midair. No, I'm not suggesting that you shoot the lights and watch them explode on impact. And whatever you do, don't stand in front of an oncoming bullet with your camera to photograph it! Studio strobes are very powerful electronic flash units. The light they emit is rated as daylight, so no corrective filters are needed when using daylight film. Studio strobes can stop all sorts of motion without the risk of blurred images.

If you plan to convert a spare bedroom, basement, or attic into a studio, you should give serious consideration to buying some studio strobes. This type of lighting is not cheap, but you can get name-brand lights that do a wonderful job for reasonable prices.

Quartz-Halogen Lights: An Alternative

Quartz-halogen lights are an alternative to flash heads for studio photography. Problems occur with flash photography. One of the most common is finding out after film is processed that the flash units created unwanted shadows. This doesn't happen with quartz-halogen lights. These lights are on while you are composing a picture, so you see the exact effect the lighting has on your subject. This is a big advantage for a lot of photographers. An added bonus to this type of lighting is that it's less expensive than flash units. A good quartz-halogen starter set will cost you about $150. It will include the lights, barn doors (which allow you to angle the lighting), light stands, and a carrying case.

Watch Out

Quartz-halogen and other photo lamps get extremely hot during use. They can easily inflict serious burns and are capable of starting fires if they come into contact with flammable materials.

One drawback to quartz lights is that they get very hot. This can make a model's makeup run and present a fire hazard if flammable materials come into contact with the lights. There is also some risk of serious burns if someone touches the lights.

Another problem with quartz lighting is that it can't stop motion like a flash unit can. Since quartz lighting produces tungsten lighting, you will also have to put a corrective filter on your lens to maintain accurate colors in color photography if you are using daylight-rated film. But, this is no big deal.

Quartz lights allow you to take normal light readings. This can be done with an independent light meter, as we will discuss in Chapter 11, or with the one that is probably in your camera. A flash meter is not required. Since quartz lights are on at all times, you can see shadows and lighting effects before you fire the shutter. This is a big help. If you want big-time lighting on a limited budget, quartz-halogen lights are the way to go.

Jargon Alert

Tungsten Light: This is the type of light that most household lights emit. It is the result of a light that uses a tungsten filament. Tungsten-rated film can be used with this light without the use of corrective filters. However, if daylight-rated film is exposed under tungsten lighting, the images will take on an orange tint. If you use daylight film with tungsten lighting, use a corrective filter to color balance your film saturation. One filter to use is an 80-A filter, but check with your film recommendations for a precise filter selection.

Ring Lights for Close-Up Photography

Ring lights are specialty flashes used with macro lenses when taking close-up pictures. These units often consist of a sensor that mounts in the hot shoe of a camera, a battery pack, and the flash attachment. The flash mounts on the ring of a lens, similar to the way a filter is mounted. Since the flash element surrounds the lens, it gives good, even illumination of your subject. Some models, like the one I have, allow you to disable one half of the ring for creative photography. Other models fire all at one time. For documentary photography of close-ups, ring lights can't be beaten.

Ring lights around the lens provide even illumination.

Flash in a Box: Portable Studio Flashes

Some photographers like to take their flash shows on the road. If you are one of these road warriors, look into portable studio flashes that can travel with you. Any studio lighting can be used where electricity is available, but if you take your photos off the beaten track, you may want some battery-powered flashes to go along with you.

Most photography doesn't require super-powerful studio strobes. If you want to take models on location and get some great shots, you can do it with inexpensive, portable, battery-powered flash units. I'm talking about the same electronic flashes that you might normally mount on your camera. These flashes, when put together with either sync cords or slaves and some light stands, make a

good substitute for expensive location kits. You can still use umbrellas and reflection cards, and you will save a tremendous amount of money.

Insider Tip

OOOH...

For less than $500, you can frequently find kits that include at least two, sometimes three, flash heads, light stands, umbrellas, a carrying case, and other accessories. Anyone with an interest in studio photography can benefit from these semi-pro lighting kits. If you decide to use this type of lighting, invest in a good light meter that takes flash readings. Otherwise, you will suffer trial-and-error exposure ratings that will be very frustrating.

Hot Shoes, Cables, and Other Flash Factors

There are a number of accessories available for photographers who use flash equipment. Whether you're using a $30 pocket flash or a $1,000 pro setup, you can always enhance your flash photography with accessories. Buying stuff is half of what makes photography so much fun! The accessories available are not mandatory equipment, but many of them can improve your photography and produce nice special effects.

Hot Shoes

We've already talked about hot shoes. If your camera has one, that's great. Don't panic if you don't have one. A sync cord will work nearly as well and in many cases is the most effective tool you can use to trigger a remote

flash. Cameras that are fully automatic are usually made with hot-shoe capabilities. This allows you to buy and use an automatic flash with your automatic camera. These flash units are remarkably accurate in their readings under normal circumstances.

Multiple Flash Sources

Many photographers advance to a point where they want remote and/or multiple flash sources. If you reach this level, you will likely use a sync cord for your remote flash. Slave devices can be used to trigger multiple flashes. There is one problem often encountered with sync cords: They don't always maintain good connections with the camera body. You can reduce flash failures by using a sync key, a small device that resizes the connection pieces to keep your connections tight. This is a very inexpensive accessory that should be kept in your camera bag or vest at all times when doing flash photography.

Slaves come in a variety of shapes and sizes. Peanut slaves are inexpensive and work well under most conditions. This is the type of slave that I use, and I recommend them highly. Most slave devices are made like a hot shoe. The ones that are not can be coupled with a remote flash by using a sync cord. The cord runs only from the slave to the flash, not from your camera body to the remote devices. Once you get to the point of doing creative things with artificial lighting, you will want multiple flashes and remote firing devices.

Studio strobes of good quality usually have slaves built into them. When you fire one light, they all go off. Before you invest in any studio strobes, make sure that they have adjustable power settings and built-in slaves. When this is the case, you only have to connect one light to your camera body with a sync cord, which is also known as a PC cord.

Filters for Lights and Flashes

Filters are available for most photographic lights and flashes. Using filters with your lighting can produce some outstanding results. Even inexpensive pocket flashes are often sold with an assortment of colored filters. Some models use gel-type filters, and others use plastic filters. It is a good idea to make sure that any lighting units you buy will accept filters for future interests in special effects.

Snoots and Barn Doors

Snoots and barn doors sound like things you would find down on the farm, but they are accessories for photography lighting. Any reputable studio light will accept these types of accessories. Barn doors consist of two or four metal flaps that allow you to angle light creatively. Snoots are used to concentrate a beam of light. They are often used to highlight a model's hair.

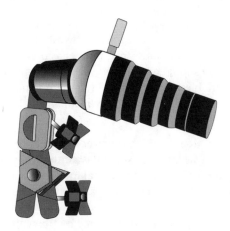

Snoots focus the light from a studio strobe.

Barn doors provide control over how much light is focused on a subject and how the light is directed at the subject.

Umbrellas and Reflectors

Most people have seen umbrellas used in flash-photography sessions. They are used to bounce light in a soft, shadowless, attractive manner. Most photographers use white umbrellas, but silver umbrellas produce more bounce. You should experiment with both types until you are comfortable with which one to use on various assignments. At about $20 apiece, they're an affordable investment.

Inflatable umbrellas are the answer to higher mobility and better results when using small flash units. These little blow-up umbrellas are only several inches in diameter, but they produce great results. They attach to an electronic flash with elastic bands. Your flash fires into the clear surface of the device and is reflected by the white or silver interior surface. You get bounced lighting from a small, portable, affordable package. I've used inflatable umbrellas to photograph modeling sessions and weddings with wonderful results. This is one accessory any serious flash photographer should own.

Reflector cards are often used in photography. They are implemented with natural light and flash photography. A reflector card can be a small, handheld size, or it can be a large unit that is supported by a stand. The painted walls and ceilings of buildings act as large reflector cards for photographers bouncing flashes. By bouncing flash or natural light with reflector cards, you receive lighting that is not harsh and distasteful. Lightweight survival blankets fold to pocket-size proportions and are often silver on one side. These inexpensive items make fantastic reflectors.

Light Meters

Light meters are critical to good photography. Most modern cameras have some type of built-in meter, but these meters can be fooled under certain conditions. The use of multiple flash units is one of these conditions. If you are going to do much flash photography with any type of flash other than a dedicated, automatic, on-camera flash, invest in a decent flash meter.

Chapter 6

Hands-On Experience

In This Chapter

➤ The eye of your camera

➤ Film speed requirements

➤ Slamming the shutter on time

➤ Ten seconds and counting

➤ Push this button before you fire the shutter

➤ Getting your film back

Cameras come with a host of buttons, levers, and functions. Figuring all of them out can take several hours. Some people never fully understand how to use their equipment to its fullest extent. Reading manuals that come with cameras is the best way to overcome the confusion of buttons and do-hickeys that you don't know what to do

with. But, suppose you buy used equipment and don't get a step-by-step manual? This chapter should help you, with or without your camera manufacturer's literature.

Spinning Your Wheel of Fortune for the Right Aperture

Aperture is the opening of a lens. Take a lens that is not attached to a camera and look through it. Rotate the aperture ring as you do this.

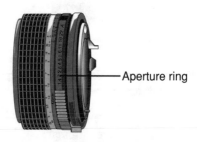

Aperture ring

Illustration of a typical aperture ring.

You will see that the light allowed through the lens is affected by turning the aperture ring. The settings you choose in this mode of photography have much to do with the finished product that you will see once your film is developed and printed.

Finding the best aperture for a picture is simple if you let an automated camera do the work for you. However, you may not get the results you want. Setting an aperture manually is frequently the only way to get outstanding photographs. In the old days, photographers made all of their own exposure settings. Today's technology has removed all but the most minimal effort on a photographer's part. This is not to say that relying on automatic settings will get you the pictures that you desire.

Insider Tip

OOOH...

To get as much of a picture as possible in focus, you must use a stopped-down aperture. In other words, you must set your aperture ring at the highest number possible when setting your final exposure.

You must use aperture settings in conjunction with shutter speeds and film speeds to achieve proper exposures. This part of aperture adjustment is essential. In addition, you can use the aperture settings on a lens to control depth of field, which determines what will and will not be seen or in focus. If you master aperture manipulation, you can do magical things with your camera.

When you choose an exposure setting for your camera, there are three elements that you must consider: film speed, shutter speed, and aperture. They all work together in a complex relationship to determine the amount of light captured on the film.

For an image to be recorded on film, the film must be exposed to light. The amount of light reaching the film and the film's speed, or sensitivity to light, control how well the image is recorded. Aperture and shutter-speed settings determine how much light reaches your film.

The faster a film speed is, the more sensitive to light the film is. In other words, film rated at ASA 400 requires less light to make a definable image than film with a speed of ASA 100. Your aperture setting controls the opening in your lens. A small aperture, one with a high number, allows less light through the lens than a wide aperture.

Lenses have different aperture settings. The number and size of the settings depend on the focal length of the lens and its cost. Expensive lenses are usually faster than inexpensive lenses. This means that they are capable of opening up more to allow good pictures to be taken in less light.

Another way of controlling the amount of light reaching the film is with a shutter-speed setting. It is not usually advisable to hold a camera in your hand with a shutter speed slower than 1/60th of a second. Shutter speed determines how long the shutter of your camera will remain open, allowing light to reach your film. A fast shutter speed, like 1/250th of a second, will allow much less light to reach the film than a slow shutter speed, such as 1/15th of a second, will.

Shutter speeds vary on different types of cameras. Some cameras don't even have shutter-speed settings or aperture rings for you to work with. When a shutter-speed dial is available, it will normally provide a range of more than one second to as little as 1/2000th of a second. If your camera has a setting for shutter speeds, it will probably be on the top right corner of the camera.

OOOH...

Insider Tip

Using a slower shutter speed when photographing a moving object will result in blurring that can translate into an image conveying very fast action.

When you take a light-meter reading with either a built-in meter or an independent meter, you will be given a suggested shutter speed and aperture setting. Remember, however, that not all cameras have internal light meters, and some cameras don't display light readings. Your camera may have a light that flashes if there is not enough light for the camera to record a good image. Some cameras read light and decide automatically when to fire a built-in flash to accommodate for low light. Ideally, your camera will give you some type of meter reading and control over what you are doing. Let's say that your meter indicates an exposure setting of 1/250th of a second at f-5.6. (F stands for f-stop. Apertures are measured in f-stops.) You can take a picture at this recommended setting, but should you? What are you photographing?

Assuming that your camera allows you to make aperture settings on your lenses, you can control the depth of field in your photographs. Depth of field has to do with what is, and isn't, in sharp focus. You may want a shallow depth of field to blur out a distracting background. Or, you might want a deep depth of field, so that an entire field of flowers is in focus.

An f-stop of 5.6 is an average setting. It will give reasonable depth of field. But, let's say that you are taking a picture of a monument. You want the background behind the monument to be blurred, so that it will not be distracting. A larger aperture opening will be needed to accomplish this. The smaller a number is in an f-stop rating, the larger the aperture is. For example, an f-stop of 2.8 is larger than 5.6.

To blur the background of a picture, you will want an open aperture. An open aperture is one where the lens opening is large. This means that your aperture ring will

be set at a small number. Each number on an aperture ring is rated as a stop. For example, if you went from a setting of 5.6 to 8, you would have moved one stop on your aperture ring. The recommended setting is f-5.6 at 1/250th of a second. In this case, you don't want too much blurring, so you decide on an aperture of f-4. This is one stop larger than the recommended 5.6 rating. To compensate for your change and to avoid overexposure, you have to increase the shutter speed by one stop. Your revised setting will be f-4 at 1/500th of a second.

If you open your aperture by two stops, you have to extend your shutter speed by two stops to maintain a balanced exposure. For every stop you move your aperture ring, you have to move your shutter-speed dial one stop. If you are opening your aperture to allow more light to reach your film, you must move your shutter speed to a faster setting to maintain an equal exposure. When you close down your aperture, allowing less light in, you must move to a slower shutter speed to maintain a balanced exposure. If you wanted more depth of field in the above example, you might choose an f-stop of f-8. Since this is closing the aperture by one stop, you have to compensate on shutter speed by one stop. The correct setting would be f-8 at 1/125th of a second.

The large numbers on your aperture ring will allow the most depth of field. In other words, more objects in front of and behind your subject will be in focus when your aperture ring is set at a high number, which results in a small aperture opening. Little numbers on the ring will blur backgrounds. This type of knowledge allows you more control over your photography. Remember though, if you change either the aperture or the shutter speed, you have to change both to maintain a balanced exposure.

This picture was taken with an open aperture, f-2.8. Notice how the center object, the subject that was focused on, is the only part of the picture that is in focus.

This picture was taken with a small aperture opening, f-32. You can easily see that this picture has much more subject matter in focus than the first picture.

Setting Film Speed on Your Camera

We've already discussed ASA and ISO ratings for film. You know the uses and advantages of different film speeds. It is important, however, that you remember to set the proper film speed on your camera when you load it with film. Failing to set a new film speed is often a source of problems for photographers. (Some new cameras do it automatically; others don't.) Even pros forget to change the speed settings sometimes.

If you don't set the film-speed dial on your camera to the proper film speed, your photographs will be either overexposed or underexposed. Not all cameras have film-speed dials. The ones that do usually have them placed on the left portion of the top of the camera. Many inexpensive cameras set their film speeds automatically and do not provide a dial for user settings. For example, if you load film with a speed of ASA 400 and have your camera set for ASA-200 film, all of your pictures will be overexposed. Loading ASA-100 film and shooting with a speed setting of ASA 200 will result in underexposed images.

Setting Your Shutter Speed

Shutter speeds are not difficult to set, but they can have a huge impact on your photographs. Slow shutter speeds are needed when lighting is poor, when film speed is slow, and when lenses are not capable of large apertures. Flash photography is normally done with a shutter-speed setting of 1/60th of a second. Fast shutter speeds are capable of stopping motion, such as a moving car, a running person, or even a soaring eagle.

You should not try to hold a camera in your hands while taking pictures at shutter speeds of less than 1/60th of a second. Movement of the camera at slow shutter speeds will result in blurred photos. Shutter speeds of 1/125th of a second or 1/250th of a second are common settings that

work fine with handheld cameras. Faster shutter speeds, like 1/500th of a second or 1/1000th of a second, should be used when trying to stop the motion of a fast-moving object.

Creative photographers often use slow shutter speeds to photograph moving subjects. The result is a blurred image, but this can be appealing.

Self-Timers Control the Action

Self-timers allow you to star in your own pictures. Set your camera on a tripod, focus it on a spot, set exposure settings, and push the self-timer button on your camera. Then, run like crazy to get in front of the lens. In a matter of seconds, the shutter will release and you will have taken your own picture. This is one use of a self-timer, but it's not the only one.

The self-timer control on your camera is very useful when taking slow exposures. Pushing your shutter button with a finger can jiggle the camera. This is all it takes to ruin a picture. When you use a self-timer, the camera settles down from your touch before the picture is taken. The result is crisper images.

Self-timers are frequently located near the shutter buttons on cameras. Some, like the ones on my cameras, allow the timer to be set for different intervals. For example, I can set mine for 2 seconds or 10 seconds. This is done by moving a little lever over either of the settings. Some cameras allow only one setting, and other cameras don't have a self-timer feature.

Checking It Out with the Preview Button

Most good cameras are equipped with preview buttons. These buttons allow you to preview the depth of field that you will achieve when a picture is taken. Few

photographers take advantage of their preview buttons, but they should use them more often. Without previewing your composition, you can't be sure of what will and will not be in focus as the depth of your shot changes.

Not all cameras are made to allow you a full preview of depth of field prior to an exposure. Check the owner's manual with your camera. If you don't have a manual, look for a button on the left side of where your lenses mount. This is a favorite location for preview buttons. If you have a preview button, use it. Seeing what you are doing before you shoot can save a lot of wasted film.

How Fresh Are Those Batteries?

You should make frequent battery checks so that you don't discover a loss of power at a critical moment. How you check the battery in your camera will depend on the type of camera you have. My cameras are set up with a test button on the top of the camera body. It is to the left of the viewfinder. When I push the button, a red light flashes on top of the camera. The speed of the flashing repetitions tells me how strong my batteries are. A faster flashing means greater battery strength. There is a good chance that your camera has some type of battery check built into it, too. Your owner's manual, if you have one, will show you where it is.

Rewinding: Where's the Reverse on this Dang Thing?

Rewinding the film in your camera should not be a difficult chore. Many new cameras rewind used film automatically. When they do this, they usually leave a short piece of the film leader exposed. This makes removing the film for home processing easier. Other cameras will rewind spent film automatically, once a button is pushed or a small lever is activated.

Watch Out

Don't get your rewind lever confused with the one that opens the back to your camera. If you do, your film will be ruined. Get to know your camera well before you put it into active use.

Old timers, like me, often use cameras where the film must be rewound manually. In my case, a small button on the bottom of my camera must be pushed to enable the film to be rewound. Once this is done, I can flip up a small crank and turn it to rewind the used film into its canister. Assuming that you want some of the film leader exposed after rewinding, you must obtain a certain feel for what you are doing. Experienced hands can tell when film has left the loaded spool, and you can usually hear the film being released.

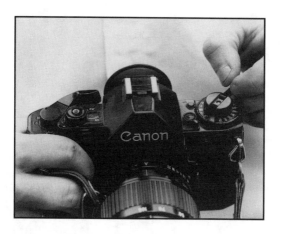

A small crank is used to rewind film in this 35mm SLR camera.

Don't panic if your film winds completely inside its canister. Professional processing labs won't mind. If you do your own processing, you can remove the film in your darkroom with a standard bottle opener. It is easier in the darkroom if you can pull film out by the leader, but this is not a big problem to overcome.

Correct Composition

YOUR THUMB'S IN IT AGAIN...

In This Chapter

➤ Horizontal or vertical framing?

➤ Low-down techniques for better pictures

➤ Creating depth of field

➤ Taking the edge off of curves and angles

➤ Breaking center-spot bad habits

➤ Cleaning out your viewfinder

Composition is a critical component of fine photography. It is often what separates snapshots from outstanding photographs. There are, of course, other elements needed to make a wonderful picture, but the best lighting, the most expensive equipment, and the finest film will not overcome poor composition. Fortunately for you, composition is not an aspect of photography that requires professional-grade equipment or a large investment of either time or money to learn.

Depicting Life Horizontally

Anyone can pick up a camera, aim it at a subject, and press the shutter release. But you probably want more in your pictures than dull images. Making your photographs interesting, exciting, and meaningful requires a little more effort and skill.

Some subjects are meant to be captured on film horizontally. Others are not. Creative photographers know no boundaries. They let their artistic senses run wild. However, art takes on many forms, and which one to use may not be so evident to you.

When your goal is to create eye-catching scenic shots, a horizontal shot is often best. Pictures of cities, houses, cars, boats, and other similar objects are normally captured this way.

One rule of thumb to remember is if your subject is wider than it is tall, a horizontal format works best. Here's an example. Let's say you're at a family reunion, and you want to take a picture of your favorite niece and nephew. How should you frame this photograph? Vertically, since two people standing side by side are taller than they are wide. But, suppose you want to take a group shot of everyone attending the reunion. This would be a good time to shoot horizontally.

Many newcomers to photography don't consider holding their cameras in any way other than horizontally. Does your camera have lettering on the top of it that says, "This end up"? Don't get locked into looking at the world in only one way; you'll stifle your creativity and lower the quality of your photography.

"Your Camera Is Sideways"

You know a person is a rookie when you are taking a vertical shot and someone walks up to you and says, "Your

camera is sideways." Look through your photo album or slide files. How many of your memories are stored from left to right instead of from top to bottom? Were most of your photos taken horizontally? Yes? Hey, turning the album sideways doesn't count!

Learning to take vertical shots comes naturally to people with a photographic eye, but the process is much more difficult for most people.

OOOH... **Insider Tip**
It is usually best to photograph individuals and small groups in a vertical format.

Go to a zoo, a park, a museum, or any other place where shutterbugs are prolific, and observe how the photographers are taking pictures. Most of them are probably holding their cameras all in the same position.

Pictures of people are almost always more effective when they are taken vertically. This is assuming that the person is standing up and is not part of a large group. If your child is stretched out on the floor looking particularly cute, or your subject is skiing, running, or involved in some similar activity, shoot horizontally. Having empty space in front of your subject gives space for the subject to be moving into. However, vertical shots are still generally best for people.

Architecture is often framed vertically. So are wildlife subjects. Common sense plays a large role here in deciding which slant to use. When you look through your viewfinder, imagine the image you are looking at hanging on your wall. Turn the camera body and view the subject

vertically and horizontally. Which looks better? Where is open space needed? As you become more comfortable with looking at your subjects through a lens, you will develop a natural feel for which angle works best.

Going Low for a Better Perspective

Lowering your body for a better perspective can produce stunning photographs. How often have you seen photographers get down on their knees to get a better angle? Or, lie down to take a picture? When you are taking pictures of live subjects, it is usually best to keep your camera at eye level with them. An adult taking a picture of another adult might do very well standing up. But, the same adult taking a picture of a child should lower the camera to the child's eye level.

Here is a cute picture of a brother and sister enjoying berries on a summer day. The picture was taken at normal adult height. Notice the bright spot of sun behind the boy's head and how the entire picture has a "looking-down" perspective. Now compare this picture to the following one.

This picture was taken while the photographer lay on the ground. Eye contact is present with the children, and there is no distracting background. Overall, this is a much better picture.

If you are taking a picture of your dog, an even lower camera level might be needed. Viewers of your photographs will want to see the subject eye to eye. If you stand up and aim down at a dog or child, the picture will not be of professional quality. Seeking eye level with your subject is a rule you should always remember. However, if you're into snakes and scorpions, use a long lens.

As a professional photographer, I've gone to great lengths, and depths, to take the best pictures possible. When I wanted pictures of pink water lilies, I didn't stand on the bank of the pond and simply snap my camera. Instead, I went into the water and got up close and personal with the aquatic flowers. If you want exciting and professional-looking pictures, you have to do more than just point and shoot. Get involved with your subjects. Try lying on your back under a colorful tree, and shooting upward. The results can be astounding. One thing, though: Make sure there are no birds sitting in the branches above you; they may decide to take target practice on you and your lens.

Put a Tree Limb in the Picture

The next time you are taking a picture outdoors, consider including a tree limb in the picture. This tactic will add depth of field to your photograph. Assume that you are standing on the shore watching colorful sailboats breeze by. You can aim directly at the boats and preserve their image on film, but the photo may not have much personality. If you position the sweeping limb of an evergreen in one corner of the picture, however, you will create a new look.

OOOH...

Insider Tip
Adding items to a photograph, such as a flower or building, will give viewers a better perspective of your subject's size.

Imagine that you are attending a wedding and want your memories of it to be special. Lots of people are burning through rolls of film with standard snapshot procedures. When it's your turn to photograph the bride and groom, you ask them to stand just on the far side of an open, arched doorway in the church. Your picture will stand head and shoulders above the rest. Adding the doorway has done many exciting things for your picture. It has provided depth, identified the location, and framed the couple. Simple little tactics like this make your main subjects stand out, and your photographs become more than casual snapshots.

Composing Odd Angles

When you slow down and look at a potential picture from all angles, you are more likely to find an ideal

composition. Simply shifting from one side to another can give you a whole new perspective on a subject. Too many photo enthusiasts rush through their picture-taking techniques and miss out on unique photos.

Buildings with dome roofs, the cap of a mushroom, and a weathered rock are all objects that curve. Photographing these objects can be especially frustrating. Finding the right composition and maintaining a good field of focus can be difficult. When you are composing a picture where curves are present, you must decide where the curves will begin and end in your viewfinder. The size of your subject will, of course, dictate how much of it can be included in a picture.

Let's use the mushroom as an example. Assume that you are a nature photographer who wants to highlight the color and texture of a wild mushroom. The mushroom to be photographed is white with brown pigment mixed in along the top cap. Pine needles cover the forest floor and create a base and backdrop for your picture. All the conditions are right. How will you compose the picture?

The first step is to squat or kneel down low, so that your subject and lens are on the same eye level. A vertical format should be used to accommodate the stem of the plant. But, where will the curve of the mushroom cap be placed? One way is to place the cap near the top of your viewfinder. Focus until the edges of the curve nearly touch the edge of the frame. The open space in each of the top corners of the viewfinder should be uniform in size. By keeping the lens level and shooting straight on in this manner, the field of focus will remain consistent. After taking this shot, experiment with shooting from the underside of the mushroom to capture the fluted sections of the umbrella.

Finding the Right Angles

Angles, like curves, can create composition problems for photographers. Learning to use angles in your composition, however, is not difficult.

Imagine a pheasant standing still, head up, tail down, posing for you in profile. Would you consider the pheasant to be an angle? Huh? Photographically speaking, the pheasant is an angle. The tail is low to the ground and the head is held high. If you could trace the bird's outline on paper, you would see a distinct angle being formed from head to tail.

The pheasant in this photo doesn't have anywhere to go. There should be more space in front of the bird. The tail feathers are angled into the bottom right corner, which is good composition, but the head is held too low.

How should you compose this picture? If the bird is standing still, one way is to put the tail in the bottom corner of your viewfinder and the head in the upper corner. This diagonal composition complements the bird's natural form.

If the pheasant were walking or running, the tail could be placed in one corner, while the head lies just above one side of the middle of the frame. This would allow space for the bird to be moving into. If the pheasant were in flight, you could put the head in an upper corner, the tail in a lower corner, and allow the outstretched wings to reach into the two remaining corners. This would be an awesome shot.

Avoiding Dead-Center Syndrome

Dead-center pictures are a sure sign of amateurish work. Many cameras have circles in their viewfinders that indicate the center point, and far too many photographers use these circles as an aiming device. Just as many people who have trouble learning to invert their cameras vertically, many photographers have difficulty breaking away from dead-center syndrome. In the case of a single-lens reflex camera, the center circle in the viewfinder is there as a focusing aid, not an aiming spot. People see the little circle and assume that it should be right in the middle of Aunt Alma's nose. Well, it shouldn't be.

Single subjects can be framed near the center of a photo, but they should be slightly above center and a little to the left or right of center. If you are taking a picture of a person but will not be doing a full-body shot, you must decide where the frame should terminate. Cutting someone off at the knees is not a good idea. Moving in closer or rearranging the subject for a better break point is more sensible.

Also, before you shoot, scan the edges of your viewfinder. Most poor composition is not recognized until the film has been developed and printed. By this time, it's too late. To avoid wasted film, lost memories, and agonizing moments reviewing your prints, clean up your viewfinder before you click the shutter.

People often photograph much more than they have to. This problem is most often associated with background interference. When a background is not adequately blurred with the use of a small aperture opening, distracting elements take away from the main subject. A common cause of unwanted interference is that photographers are so focused on their subjects that they don't notice surrounding objects. If you spend all of your energy concentrating on your subject, you are sure to make some mistakes in composition. There is, however, a way to avoid this: Compose first, focus second, and then compose again.

After you have done your initial composing and focusing, scan all areas of the viewfinder for distractions. Start by going from edge to edge and corner to corner. Next, look for background flaws. If your camera has a depth of field preview button, use it. Many good pictures are tainted by busy and distracting backgrounds. Use a long lens or an open aperture to blur out such confusion. You want your subject to be the focal point of the picture.

Reflections, Shadows, and Other Hazards

Have you ever taken a picture of someone or something standing in front of a window or glass door while using an electronic flash? If you have, you've probably been plagued by blinding reflections of the flash in the glass. Avoid this during the composition stage by pulling drapes or curtains closed, or by relocating your subject.

OOOH...

Insider Tip

When using an electronic flash, don't allow your subject to be placed in front of a reflective surface.

Shadows can also be a big problem when flash pictures are taken. Get your subject to move well away from any wall or surface that might show off a shadow. By simply moving your subject during composition, you can save yourself from the shadow monster. If you're on vacation and taking family portraits, beware of signs, posts, and other objects that might sneak home with you in your film canister. You must preview pictures before you take them.

If you can use a tripod to hold your camera, the process of checking a viewfinder is easier. The use of a zoom lens makes it easy to crop out side interference, and a fixed lens can eliminate bothersome images if you simply change position. The bottom line is this: Don't push the shutter button until you are sure that the viewfinder contains everything you want and nothing that you don't.

Lighting Techniques

There is an old saying in the real estate business that there are three things important to a property's value: location, location, and location. A similar statement could be made about photography. What three things make or break a photograph? Light, light, and light. Of course, composition and exposure are both important elements of a wonderful picture, but light is frequently what makes a picture a winner or a loser.

As you progress in photography, you will probably work with various types of lighting. Natural lighting and artificial lighting are the two broad categories, but these areas break out into a number of different lighting situations. You might be working with household lighting, electronic flash, fluorescent lighting, sunlight, photo lamps, and so forth. You will have to adjust for and adapt to the type of lighting that you are using. To do this, you must learn the principles of good lighting.

If I were to guess, I'd say that most photographs are taken with natural lighting. A lot of professionals use artificial lighting, even outdoors, but pros don't account for the mass number of photographers. People like you, who pursue photography as a hobby, are much more numerous than professionals.

So, if pros use artificial light so frequently, why don't you? I believe the answer is that natural light is easier for an amateur photographer to work with. Professionals often want to control every element of their shots. This is rarely the case with casual shutterbugs. But, to get the most out of your pictures, you have to learn to use natural light correctly.

Back Lighting Turns Dew into Jewels

There is some unwritten rule among amateur photographers that says the sun should always be at your back when taking pictures. This type of logic is what separates the pros from the rookies. Back lighting a subject often makes a picture much more appealing.

Watch Out

Beware of hotspots when back lighting.

Back lighting is when the light for an exposure comes from behind the subject. This type of lighting is done all the time by pros, but few weekend warriors do it. Set yourself apart from the crowd and start back lighting your subjects. I'll even tell you why and how to do it.

The occasions when this type of lighting is appropriate are numerous. Let's look at two examples of its benefits.

In our first example, you are a studio photographer working with a female model. The model has very nice hair, and you want her mane to stand out from the blue background you are using. To do this, you should use a hair light. This is typically a studio flash with a snoot attached to it. The snoot is a tube that narrows the beam of a flash. When you shoot your exposures, the snoot will blast light into the back of the model's hair. By doing this, the hair will almost glow, and it will not melt into the backdrop.

Maybe you aren't into studio sessions with models. Maybe you prefer nature photography. Well, let's say that you are out on an early-morning walk when you come across a spider web covered in dew. The spider who made the web is resting comfortably in the center of it. Looking at the web, you see that it is suspended between two trees, offering you an opportunity to shoot it from either side. Which side will you choose? Where is the light coming from? Early-morning light is low and angled. If you can get it behind the web, you can make the dew stand out like jewels surrounding the princess of the web. You can take a good picture with the sun behind you, but a great picture will result from having the sun behind the web.

Back lighting works well for separating your subject from a background. This is a factor both in a studio and in the woods. In addition, it often makes a subject seem to sparkle and stand out from other elements of a photograph.

You can also use back lighting to create silhouettes. If your subject is in front of a light source, take a meter reading on the bright background. Set your exposure for the background exposure. This will turn your subject into a silhouette.

Rim Lighting: Not Just for Basketball Stars

Rim lighting is related to back lighting, but with a few significant differences. When a subject is posed with rim lighting, the light source is behind the subject, as with back lighting. But with rim lighting, the light is also either higher than the subject or to one side of the subject, perhaps both. This creates a nice effect.

Rim lighting is very effective when you want to bring out the shape of a subject. Think of a silhouette that has lighted edges, and you can begin to see what a rim-light shot will be. Flowers, people, bottles, almost anything can be photographed with rim lighting. The times when you use this type of lighting will not be numerous. For most photographers, rim lighting is a rare feat. However, the effects are so powerful that you should at least experiment with them. There are certainly times when no other type of lighting can do a subject justice.

Creating Depth and Form with Lighting

Learning to use light to make images that a sculptor would appreciate takes practice. But, it can be done. A lot of photography is based on shape and texture. To bring out these two elements, you must have a strong grasp of lighting techniques. Let me give you some examples.

Side lighting (light hitting a subject from one side) is used to bring out the texture in a subject. If you want your pictures to have as strong a three-dimensional look as

possible, use side lighting. The drawback to side lighting is that you don't fill in shadow areas and get a full and complete lighting situation. This is often advantageous, but you must learn when by practicing with various types of lighting.

Back lighting and rim lighting give you strong shapes, but not much detail. Since the lighting is behind your subject, you are forced to accept the shape and structure as your subject. This can be a powerful tool, but don't expect to see smiles on the faces of people who are back lighted or rim lighted. It's not because they are unhappy, it's because the light is not on their faces.

Front lighting is when you have the sun at your back and in your subject's eyes.

 Watch Out

Front lighting often results in unwanted shadows on a person's face. Solve this problem with fill flash.

This is the typical lighting arrangement for most photographers. When you opt for front lighting, you will get good color saturation and a lot of detail in the face or frontal part of your subject. Shape and dimension will be minimized. Simply shifting your position by a few feet will alter the lighting enough to create a different type of picture.

How you position your lighting, whether in a studio or out in the field, will affect the appearance of your subject. Once you understand the basic principles of different lighting positions, as we have just discussed, you can control your images. It's really not difficult. You can choose

between only four fundamental lighting circumstances: side light, front light, back light, and rim light. Each one gives you a different perspective. If you are in doubt of which one to use, use them all. Photographers who are afraid to shoot multiple shots at different angles and exposures are photographers who come home with boring pictures. Splurge a little on your film and processing. The end results will prove satisfying.

Warm Glows in the Afternoon

Afternoon sunlight gives a warming effect to photographs. This is often a pleasing and appropriate type of light. You can even enhance the warming effect with filters. If you are interested in landscape photography, mid to late-afternoon lighting is probably what you will want to use.

OOOH...

Insider Tip

You should buy a photographic gray card and carry it with you to get ideal exposures. This card is gray in color and is used to measure accurate exposure readings. All you have to do is hold the gray card in whatever light your subject will be in and take a meter reading from the card. You can use an independent light meter or one that is built into your camera.

Many types of pictures benefit greatly from the warming effect of afternoon lighting. Consider an old barn with weathered wood siding. Try to visualize the siding. It is gray for the most part, with many deep brown segments. Old square nails hold the rotting wood in place, and the heads of the nails have turned to a bronze color with rust.

Cracks in the siding leave shadow-filled voids. Shooting this scene with front lighting in the early morning would probably be a waste of time. However, a side-lighted shot in the afternoon would pull out all of the color and texture. The afternoon light would make the brown spots darker, and the nails would stick out as miniature main subjects.

Afternoon lighting is ideal for hay fields, earth-tone colors, human complexions, and a lot of other subject matter. Typically, the lighting you get late in the day is the best photographic lighting that you can use. There are, of course, exceptions to this rule. But, it's hard to beat warm images that have their shadows cast well out of range of your lens.

Cool, Powerful, Electric Vibes with Morning Light

Shooting early in the morning will give you very different results from what you will get in the latter part of the day. If you are a morning person, you will be faced with natural light that can tint your shots in a haze of blue. This effect can be reduced with corrective filters. However, you might like the bluish tint.

Advertisers have told me for years that blue is a power color. Many ad campaigns have been built around electric-blue backgrounds. Is blue a power color? I don't know. Some say blue is boss; others say gray is good. I'm not an advertising guru, so I can't really say. I do know, however, that if you are using slide film with a fast rating, the blue tints from morning light can be very blue. So blue, in fact, they'll turn you blue once you see what you thought was a great picture.

There are reasons, mostly commercial, to take advantage of cool, blue lighting. As a not-for-profit photographer, you may find that using corrective filters will make you

happier with your early-morning shots. Maybe you want blue, maybe you don't. Personally, I don't shoot many blue shots. Misty shots are a different subject altogether, and they are often available only in the early part of the day, so let's talk about them next.

Misty-Morning Shots

Some of my fondest photo memories have been made on misty mornings in the mountains. An early sun rising behind dew-laden hemlock trees is a perfect backdrop for my camera. The back lighting and rim lighting make nature's splendor soar. Foggy mornings can also induce a photographic mood that is unparalleled. Whether you are on a beach, in the mountains, or floating across a mirror-still lake, morning light can give you photographs that you can't get under any other circumstances.

If you choose to shoot on misty or foggy days, you might want to experiment with your exposures. Overexposing your film can add to the coolness of these types of pictures. You can overexpose your film by setting a shutter speed that is slower than what your light meter calls for or by opening your aperture to a wider stop. A rising fog or a light drizzle of rain gives a scene a perspective that you won't get on clear days. You may not like the isolated feeling or the sterile look of misty photos, but don't knock it until you try it.

OOOH...

Insider Tip

If you take your photographic gear out in a canoe or boat, invest in inflatable pouches that will protect your valuable equipment if it should wind up in the water. These pouches can hold a lot of stuff, and they work wonderfully.

Cloudy Days Spread the Light Around

When you want to take portraits of people outdoors, try to work on cloudy days. I'm not suggesting that you take your subjects out under the veil of dark storm clouds. Choose a day when cloud cover is uniform and light. The ideal circumstances will have the clouds acting as a diffuser for the sunlight. When this is the case, you can take fast exposures on slow film and not be worried about shadows and harsh lighting.

Portraits of people are not the only types of pictures to take on overcast days. Many subjects can benefit from diffused lighting. Landscapes will not be as dramatic, but any portrait-type picture will normally look better if it is taken with subdued lighting.

Natural light, and we're not talking about the beer, is a strong tool for you to work with as a photographer. Learning how to use it to your advantage will take some time. You will experience bad exposures, shadows, sun flare, and other common problems as you begin to master outdoor lighting. But, once you tame the beast, it will be one of your best friends.

Chapter 9

Picture Perfect

THIS IS OUR ANNIVERSARY PARTY. SHOT A LITTLE HIGH...

In This Chapter

➤ No driver's license photos allowed

➤ Capturing kids on film

➤ Head shots that stand out

➤ Travel photos

➤ Covering the bases

➤ Sharp as a tack, or not!

How many people like the picture on their driver's license? Not many. The pictures on licenses are usually lighted properly and provide an accurate record of a person's appearance, but this doesn't make them good photos. Few people frame their expired driver's licenses and hang them on a wall. As a photographer who is building skills, you have to reach beyond simple recording and put feeling into your photos.

What separates a memory from a mug shot? Many elements enhance the beauty and meaning of a photograph. Whether your subject is the Statue of Liberty or your child, the feeling and mood with which the subject is captured on film set the pace for your work. Film speed, aperture, and exposure settings are tangible aspects of photography. Feeling, mood, tone, texture, and technique are more difficult to describe. Yet, it is these very concepts that you must grasp to go beyond backyard pictures.

When you set out to make memories, you must look for certain elements in a picture. What will make the shot you take special? Are you recording the existence of a monument to prove that you crossed the Continental Divide, or are you telling a story with your camera about Native American culture? The subjects of your work and the conditions under which you are shooting play a part in how you should make your memories.

Up until this point, we have been discussing basic photography principles and practices. This chapter marks the beginning of a new approach. We are going to talk about making professional-type photographs now. The pictures that you take from this point on can have the professional look and a power that is beyond words.

People and travel interests are often key subjects of amateur photographers. It just so happens that these two popular photography subjects are also the main focus of this chapter. We will start our move into interpretive photography with people and expand into travel photos. You may want to take notes as we proceed from this point. In doing so, you can put professional photography techniques to work for you as soon as you pick up your camera the next time.

Children Can Be Challenging

If you have children, they will probably be one of your most-photographed subjects. Children can be very challenging subject matter, though. They move quickly, are unpredictable at times, and almost always go out of their way to ruin a picture if they know one is being taken. If you want to capture your kids on film in natural poses and settings, you may have to do it from a distance.

Insider Tip

Use a long lens and a fairly fast film when capturing candids of kids. Think of yourself as a wildlife photographer and your kids as the wildlife. Hey, they're probably pretty wild, so they qualify.

Art Linkletter used to say that kids say the darndest things. Well, they also do the darndest things. Unfortunately, your camera may not be handy at the moment you need it. There are several rules to photographing children for outstanding results. Rule number one is having your camera ready at all times, and I do mean at all times.

One of the most treasured photos of my daughter was taken under unusual circumstances and with difficult lighting. Afton, my daughter, was sitting in the back seat of my 4 × 4. Her mom had gone into a convenience store to get some refreshments. I was sitting in the driver's seat, cleaning the lens on my camera. We were headed to a small zoo, and I planned to get some good animal shots. When I looked over my shoulder, Afton looked adorable. Without a light meter or a moment's notice, I turned the

camera and fired three or four exposures. When the slides were processed, the results were more than I had hoped for. This type of impromptu shooting can result in fantastic photos.

The true key to success in getting memorable shots of your children is being ready at all times. If you need a point-and-shoot camera to be ready, get one. Fancy 35mm equipment will often allow you to do a better job, but it's useless if it cannot be pressed into service quickly. Medium-format cameras are ideal for portrait work, but they are often too cumbersome and slow to use in the pursuit of child photography at real-time speeds. Shooting in a studio is one thing, shooting on-the-fly is quite another, and on-the-fly is where the best pictures are captured.

There are some basic guidelines that you should follow when taking pictures of young children. First, be ready for fast action that doesn't last long. Children in motion can be difficult to stop, with a camera or anything else. If you are shooting indoors, have a good, preferably automatic, flash unit on your camera. Choose a film speed that is fast enough to give you the shutter speeds you need to stop action.

You should shoot at shutter speeds of at least 1/125th of a second. Shooting at 1/250th of a second is better. This means that you will need either fast lenses or fast film. Remember, fast film results in grainy enlargements. An ASA-200 film is a pretty solid all-around film for chasing after children on the move.

A zoom lens is a great idea when chasing after children. If you are working with kids on the move, you have to react quickly. Take meter readings before you plan a shot. Get a good idea of what exposures will work and try to bracket shots as often as possible. Few toddlers are going to hold their poses long enough for you to take an independent

meter reading, set your controls, and snap the shutter. You have to act fast.

I'm going to talk about candid photography in the next section, but I want to mention it here, too, because it pertains especially to children. Posed pictures are rarely the best pictures possible. This is true in most circumstances, and it is especially true when photographing kids. Many children will ham it up for a camera if they realize they are having their pictures taken. To get the best shots of your kids, you have to catch them off guard. You don't have to have a long lens to do this, but you must be a little sneaky and very fast.

Point-and-shoot 35mm cameras with telephoto lenses and built-in flashes are excellent for quick kid shots.

Insider Tip

OOOH...

While a point-and-shoot camera is not capable of the versatility and quality that component systems offer, it is an excellent choice for shooting from the hip to catch your kids on film.

These cameras can be concealed in a jacket pocket and put into use very quickly. When you combine all the attributes of 35mm point-and-shoot gear with the low cost of acquiring this type of gear, it's very hard to beat.

Medium-format equipment should not be considered useless when capturing kids on film, but it is the most difficult type of camera equipment to use for fast shots with kids. A single-lens reflex 35mm system is an excellent choice if you are familiar enough with it to use it quickly. A zoom lens is advantageous on any camera used to

photograph active children. Some type of onboard flash should also be considered needed equipment.

Captivating Candids and Praiseworthy Portraits

Candid photography is often the best way to preserve the true feeling of a person. As I said earlier, posed pictures are rarely outstanding. Portraits are typically posed, but some of the best shots derived from a portrait session often come from casual candids.

You can get this type of candid shot if you are ready for it and act quickly. Notice how the photographer knelt down to shoot at eye level.

There is a time and place for stiff, posed pictures, but few photographers ever fall into these situations. The best photographers are known for their ability to record natural scenes.

If you want posed pictures of your spouse, children, or friends, send them to a quickie studio where you get a

zillion photos for one low price. You know the type of pictures I'm talking about. Fake leaves, painted Christmas scenes, and similar unappealing backgrounds are generally a part of these discount portraits. You can go to a studio photographer who will do a good job with better backgrounds, but you will still wind up with posed pictures. To make true memories, you have to capture the human side of your subject. The same basic principle applies to pets, even though they are not human.

Photograph your subjects in natural settings. If you ask children to sit on a stool and look pretty, you will get the equivalent of school photos. If this is what you want, fine. However, if you want pictures of your kids building a snowman or catching a fish, you have to work outside the parameters of studio photography. Essentially, you must take their pictures without their realizing that the camera is working.

Getting good pictures of people can be difficult. Most people, kids and adults, tense up when they know a camera is looking their way. Those who don't get tense often act silly. We've all seen the fake smiles and strained expressions that are so common in portraits. To avoid stiff pictures, you need to get your subjects involved with something other than posing and saying cheese.

Candid shots are usually done on impulse. If they are planned at all, only the photographer knows it. So, how do you get planned portraits to look like candids? It's easy. Give your subject something to do while you are "testing" your camera's meter, battery, or whatever else will give you an excuse to be holding the camera in firing position. When your subject is engrossed in the task you have assigned, fire away. Focus on the back of your subject's head, and then call to the subject. When the person turns around, click the shutter. By catching your subjects with unexpected shots, you should get better, more natural pictures.

On the Road Again

Vacation photos can be very boring to look at. Anyone who has ever had to sit through a slide show of typical travel photos knows this to be true. You can spice up your travel shots by taking a different approach. It's okay to do some recording photography when you are traveling. Pictures of monuments, signs, and places that are taken from a cold, static point of view are all right now and then. However, good travel photos are not merely evidence that something exists. Great pictures tell a story. Let's look at some examples of this.

OOOH...

Insider Tip

People will be much more likely to enjoy the next slide show of your recent vacation if you learn to take pictures in such a way that they tell a story.

Let's say that you and your family are going on a rafting expedition. You are the photographer. How are you going to take pictures of the trip? Here are two suggestions. Ride in a raft in front of the one that your family is riding in. This will allow you to turn around and shoot directly at the faces of your family. Want a really neat shot? Lie down on the riverbank or wade out into the water and shoot with your camera near the water level. Most people would stand on the bank to take pictures of their subjects. Getting down low will give the picture more perspective. Change your shutter speeds. Shoot some film at fast speeds to stop all the action. Then, use slower speeds and pan with the raft to show speed and interesting water designs.

Maybe rafting is not among your vacation plans. Let's say that you are going to Maine. Your trip will include visits to small harbor towns. Lobster boats bob in the water. Weathered docks are stacked high with lobster traps and buoys. How will you record your trip to a working lobster harbor? One approach might be to use a wide-angle lens that will cover the scene completely. This is a typical tourist shot. Instead, get personal with your subject. Use a longer lens and isolate individual subjects. Use the colorful buoys and crusty lobster traps as foreground when taking a picture of the boats. Shoot the wide-angle shot, but then work the harbor with different lenses. Change positions and try to include people in some of your pictures. Putting people in travel pictures helps to make the images more interesting.

When you photograph landmarks, look for unusual angles to shoot from. A straight-on shot of most any landmark will be uninspiring. Grouping your family in front of a sign or monument is one way to prove that you've been there and done that, but it doesn't hold a viewer's attention. Use the signs and monuments as foreground or background for pictures that will be more interesting. When possible, have your family involved in some activity when recording your vacation shots. A kid splashing in the surf at a beach can be interesting. If the dock in the background sports a sign that tells where you are, so much the better. Avoid the typical posed pictures.

Bracketing Exposures to Ensure Success

The best way to beat the odds of bad exposures is to bracket your pictures. This simply means shooting the same scene several times at different exposures. Many photographers shoot one shot at what they believe to be the best exposure and then shoot a frame at one stop slower and one stop faster than the optimum exposure.

For really important pictures, give yourself more latitude by shooting five shots of the same scene. Light meters can be fooled, but bracketing will hedge the odds of success in your favor.

Fuzzy Focus Fiascoes

Fuzzy focus in a picture can be very disappointing. And unfortunately, this problem occurs frequently. You may be in a hurry to get a shot and fail to tighten up the focus. Maybe you will be shooting at a slow speed without a support and wind up with a blurred picture. It doesn't take much to have a picture out of perfect focus. This is, however, something that you can control. Take your time. Focus carefully and then recheck the focus before you shoot. Most focusing problems are caused by photographers who are rushing to get a shot or who are not taking their work seriously. All you have to do is slow down and check your viewfinder before pushing the shutter button. By doing this, you can avoid the frustrating feeling of seeing your prize pictures turning out as fuzzy messes.

Taking Pictures Indoors

In This Chapter

➤ Avoiding ugly yellow tinting

➤ Fast and grainy film

➤ Flashing: How far is too far?

➤ Gang flashing

➤ Follow the bouncing flash

➤ Busy backgrounds

➤ Instant backdrops

Indoor photography can provide you with endless photo opportunities. When you take pictures indoors, you are unaffected by the weather outside. You can create your own conditions for fantastic photography. A studio isn't needed; your living room will do just fine. It doesn't take much to set the stage for a lot of fun when you practice your hobby indoors.

Indoor photography normally requires the use of either fast film or some type of artificial lighting. Unfortunately, fast film produces grainy pictures, while artificial lighting can be bothersome to set up and work with. Learning to produce good pictures indoors can require patience and practice. Electronic flash is the typical choice for artificial lighting. The bad part about flash units is that you can't see what they are doing until they are done. This means that your pictures may not turn out so well. There are four basic aspects of indoor photography that you must learn, and they are all about to be discussed.

Filtering Out Incandescent Light to Avoid Yellow Tinting

When you buy film for your camera, it will probably be daylight-rated film. This simply means that the film is intended to be used outdoors with natural light. Using this film in a home with household lights can result in some ugly pictures. The film will take on a yellowish-orange tint. Seeing faces of loved ones turned to a jaundice color is not pleasing.

Incandescent light is the type of light that comes from an ordinary light bulb. This type of light does not work well with color film. Some film is rated for tungsten light, which is the type of light given off by photo lamps. However, most film is rated for daylight use. Daylight-rated film can be used with sunlight or electronic flash, but should not be used with incandescent or tungsten light, unless a corrective filter is used to balance the lighting.

There are two ways to avoid pale pictures. You can either use film rated for indoor use or put a filter on your lens. Indoor film is rated for tungsten light. This is the type of light that you get from photo lamps, not household lights. If you are going to shoot in your home with light that is produced by typical light bulbs, you must filter

your film. Otherwise, your pictures will have ugly tints in the color. (Daylight film is balanced for light from an electronic flash, so no filter is needed when using an electronic flash with daylight film.)

Film rated for daylight use should be filtered with an 80-A (blue) filter when used with household lighting. Tungsten film should be filtered with an 82-C (blue) filter. If you use daylight film with photo lamps, an 80-B (blue) filter should be used. Using tungsten film outdoors or with electronic flash requires an 85-B (orange) filter. Any photo store should carry all of these filters and charts for other filters that you might want to experiment with. See Chapter 14 for more details.

Beating Bright Spots

Indoor photography can often be plagued with bright spots. This comes from light being reflected off some object in the picture. Common sources of bright spots include television screens, mirrors, picture frames, and even bright walls. Common sense is your best defense against this problem. Don't place your subjects in positions where reflective surfaces will bounce light back at you. Putting a person in front of a window or glass door is a common mistake. Not only will light from the outside affect your exposure reading adversely, the glass is likely to throw your flash right back at you.

OOOH...

Insider Tip

Remember that polarizing filters are essential equipment when shooting into a reflective surface, such as glass or water.

Bright spots are most likely to haunt you when you're us-
ing an electronic flash. Since you can't see the result of
your flash until your film is developed, you won't notice
the bounce-back until it's too late. If you're using photo
lamps, you can see what the lighting is doing. Scan your
viewfinder for any indication of hotspots before releasing
the shutter. As a basic ground rule, keep your subjects
away from reflective surfaces. Installing a polarizing filter
on your lens will reduce the glare and the reflections from
glass and other reflective surfaces, including eyeglasses.

Granny's Grainy Pictures

Some photographers turn to fast film as a substitute for
good lighting. As you learned in Chapter 4, the faster a
film is, the grainier your pictures will be. While the grain
might not be distracting in a snapshot, it will surely show
up in enlargements. There is only one way to avoid grainy
pictures. Use slow film. A film speed of ASA 200 is about
the fastest you can use and still obtain reasonably good
quality in moderate enlargements. Slower films are a bet-
ter choice when you plan to have your prints enlarged.

When you slow your film down, you have to have fast
lenses or provide plenty of light. Fast lenses are ones that
allow a wide aperture, such as a rating of f-2.8. An elec-
tronic flash is the best way to compensate for low light
levels or slow lenses and film. I shoot mostly slide film.
My standard film speed is ASA 64. When I anticipate hav-
ing my slides printed as enlargements, I slow down to ASA
25. If you're shooting negative film, an ASA of 100 is a
good all-around choice. It gives you a fairly fast speed
with minimal grain.

Knowing Your Flash Limitations

If you are using an on-camera flash, you must know what
its distance limitations are.

Jargon Alert

Strobe: This is a slang term for an electronic flash. It is common in photographic jargon.

While you will almost never have a problem with distance in your home, you can run into other indoor situations, such as a big party or a concert, where your flash simply isn't powerful enough to reach out and light your subject. An electronic strobe with high output can solve this problem.

If you are going to use an electronic flash often, you should get to know your flash unit very well. One of the best ways to do this is to take a series of test shots. Talk a friend or family member into being your photo guinea pig. Have the person stand at a measured distance from your camera and flash. Ask your subject to hold a card that indicates what the distance and exposure settings are that you will be shooting with. Experiment with different distances and different exposure settings. By working under controlled and recorded conditions, you can determine exactly what areas of your expertise require attention.

After your test film has been processed, review it and note the results of your shots. At what distance was your subject getting out of range of your flash? When was your subject too close to the flash? Was red eye a problem? Did your flash cover the full area of your lens perspective? This type of visual evidence will make it easy for you to know and understand your lighting equipment.

If you are using a flash unit that has a distance scale printed on it, use the information. It will usually be correct. Most flashes have a chart where you can find the

ASA/ISO speed of film and the distance at which to shoot to determine the correct aperture setting when the shutter speed is set at 1/60th of a second, which is the standard shutter speed for flash photography.

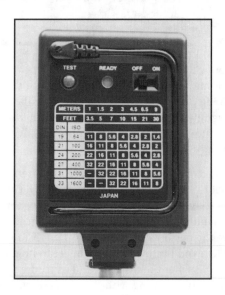

Many electronic flashes, like the one pictured, have distance scales on them.

If your flash is an automatic-only unit, you will not have any creative control over it. In this case, you must do enough test shots to get to know your flash extremely well. This is normally the case with point-and-shoot cameras. Some flash units work automatically but allow you to control settings. These models use a sensor to gauge the amount of light needed to illuminate an image. As with other automatic functions, these devices frequently produce satisfactory results. They can, however, be fooled. There is no replacement for the benefit of test sessions and experience. Shoot several rolls of film while learning

the limitations of your flash. You may feel like you are wasting good film, but the lessons learned will serve you well in the future.

Making the Most of Multiple Flash Units

A single flash unit is better than no flash, but it's hard to beat a multiple-flash setup for quality lighting. With the right flash equipment and enough experience, you can take pictures that will rival those of studio artists. And you don't have to spend thousands of dollars on lighting equipment to do it.

How you mount or arrange your flash equipment will depend on your personal preferences and working conditions. You might use a bracket to hold a flash on each side of your camera. This will eliminate red eye and give good, even lighting, without heavy shadows. Light stands work very well as supports for flashes, and they aren't a big bother to set up and take down. Any flash unit designed to slide into the flash shoe of a camera can be mounted on a light stand. You will need an inexpensive adapter, but you can get it from your local camera store. It's a simple metal piece that slips over the foot of your flash. The adapter is tapped with threads so it can be screwed onto the threaded rod of a light stand or tripod.

When you set up multiple flashes, you can use tripods, tabletop tripods, or light stands to achieve versatility and varying heights. In a pinch, you can even lay a flash on a flat surface, such as a window sill or shelf.

Once you have your flashes situated, you need a way to fire them in unison. One of your flash units will have to be the dominant flash. This may be an on-camera flash or a remote flash that is connected to your camera with a PC cord. Other flash units can be fired with the use of slave units. Peanut slaves are tiny, inexpensive, and work very well at normal shooting ranges.

Jargon Alert
Slave Unit: A slave unit is a device that is used to fire multiple flashes simultaneously.

These slaves plug right into the connectors on remote flashes. All you do is slip the slave connector into the PC plug on the flash, and you're in business.

When using slaves, your primary flash will fire and trigger other flashes that are equipped with slaves to fire simultaneously. This type of system is very effective for a number of uses. You can use it to light portraits, stop motion, color scenes with filtered flash heads, and so forth. For under $100 you can have an effective multiple-flash system.

Off the Wall, or Off the Ceiling

Bouncing a flash off a wall or ceiling is a good way to get soft lighting without shadows. When you take a picture of a person with direct flash, you can experience red eye, forehead reflections, and plain old ugly lighting. Bounced flash avoids this. Obviously, if your flash is built into the body of your camera, you can't use it to bounce light. But, if your flash mounts in a flash shoe or is used off the camera, you can bounce to your heart's content.

Many inexpensive flash units don't swivel or tilt, but some do. Buy one that does. At the very least, get one that tilts. You can use a small reflector card with these types of flashes to help diffuse your lighting. If you are setting up multiple flashes on stands, you can aim them in any direction. The movement of the head on the stand or tripod on which you are mounting the flash will give you mobility.

A neat little rig that I've used often is an inflatable bounce bag. It's basically a balloon that is blown up and strapped to a flash head. The flash fires into the balloon, and a white or silver lining reflects the light back on your subject. These inflatable mini-umbrellas work very well, don't take up much space, and are easy to use even with shoe-mounted flash units that swivel.

Standard photo umbrellas can be used to bounce light, but you must have a pretty powerful flash head to get any real distance out of an umbrella. An alternative to umbrellas is reflector cards. These can be as small as a business card or as large as a sheet of plywood. Colors are normally white or silver, but other colors can be used for special effects. Experiment with bouncing flash from various angles and surfaces to see what effects you like best.

Doing Away with Distracting Backgrounds

Busy backgrounds can detract from a picture. If you have a person standing in front of a drapery that includes a complex pattern, the background might make your photograph undesirable. The same thing could happen if your subject stood in front of a wall where wallpaper created a maze of patterns. Since you can't always control the background that you have to work with, you must learn to tame it with your aperture setting.

The more open an aperture is, the less depth of field you have. Let's say that you want to take a picture of visiting relatives. Also assume that the room you have to work with doesn't offer a great background appearance. First, have your subjects stand as far away from the background as possible. Then, open the aperture on your lens to its widest opening. This combination will put your subjects

in focus and the background out of focus. A busy background that would be a distraction if it were in focus can make a pleasing backdrop when it is blurred together with a wide aperture.

All you have to do to reduce the effect of unwanted background is to move your subject away from the background as far as possible. Use the longest lens that you can, and open your aperture as wide as it will go. Keep in mind, however, that you must coordinate your aperture setting with your shutter speed. An open aperture will result in a faster shutter speed. This combination will make the background a blend of color rather than a distracting design.

Portable Backdrops that Set Up Quickly and Work Great

If you do much indoor photography where you want portrait-style pictures, invest in some portable backdrops. Your choices for backdrops are vast. You might pick blue velvet, gray paper, or black satin. Most camera stores stock a variety of background materials. You can even buy background scenes that look like waterfalls, Christmas scenes, and other outdoor and festive occasions.

Once you have your background material, you need an easy way to deploy it. I discovered a very effective way of doing this that is both portable and easy, while remaining inexpensive. Go to a local hardware or building supply store. Buy a wooden closet pole. They come in various lengths, and you can cut them a few inches longer than the width of your background material.

Drill a hole in each end of the rod, about three inches from the edge. The holes should be large enough to allow the threaded studs of a light stand to fit through them.

Staple your background material to the closet pole. It can then be rolled up on the pole and stored. If you buy background paper, you can slide the closet pole through the cardboard spool that the paper is stored on.

Set up two light stands and install the pole over the studded heads of the stands. You can raise or lower the pole at will. Once the pole is mounted on the stands, you can unroll the background and have a perfect shooting situation. Your shots will have professional-quality backgrounds with no distractions.

Everything Under the Sun

In This Chapter

➤ Dealing with ever-changing light

➤ Don't use it, diffuse it

➤ Wet-weather techniques

➤ Outdoor composition

Outdoor photographers have to deal with changing light conditions, wind, and a number of other uncontrollable obstacles. Are they really uncontrollable? Not as much as you might think. When you take your camera outdoors, you will face different challenges than you would in a studio. They are not necessarily more difficult to deal with, but they are different.

With so many people pursuing outdoor photography, companies have responded to the needs of these photographers. With a combination of skill, experience, and accessories, you can tame much of what Mother Nature has to throw at you.

Lighting Up the Great Outdoors

Since lighting is such a critical element of photography, let's start this chapter by looking at some common lighting problems you may see with outdoor photography.

Changing Light Conditions

When you choose to use the sun as your light source, you have to be prepared to deal with changing light conditions. As a part of this, you must put up with shadows that move as the day grows longer. Since shadows can be a photographer's friend, you shouldn't get too upset. However, your shadow friend can become your enemy if you are not prepared for what's to come.

Outdoor light can change in a moment. If a cloud passes between your subject and the sun, the exposure reading you took moments before will be useless.

OOOH...

Insider Tip

If you are taking pictures on a day when cloud cover is moving across the sky, try to take meter readings between each exposure. Shooting with a motor drive or auto-winder can be done in consecutive shots without new readings, but monitor the conditions closely.

Outdoor photographers must be in tune with their lighting conditions and must check them frequently. Reading the instructions that are packed with film might lead you to believe that you can adjust your camera for set exposures and enjoy a great day afield without changing your controls. Don't even consider this line of thinking.

A common mistake made by many photographers is to take a benchmark light reading and stick with it throughout a photo session. This can work in a studio, but it probably won't produce favorable results under the sun. It's not always necessary to meter every exposure, but you must keep track of what nature's light is doing.

If you plan to photograph a subject that is in a shadow, you must be particular about the way you take a meter reading. Assuming that you are standing in the sun, your light meter will be fooled by the subject that is shaded unless you are using a spot meter. Any type of reflective, incident, or averaging meter will have trouble giving you an accurate exposure rating for a subject in the shade while you are standing in light. Move up close to your subject. Get in the shade yourself and take a reading. Then you can move back from the subject and get your shot. A spot meter is the only type of meter you can depend on when you are in the sun and your subject is in the shade.

What do you do if your subject is partially in the sun and partially in the shadows? Well, you can't have your cake and eat it, too. You must decide what portion of your subject is the most important to your photograph. Move up close to the subject and meter on the primary spot of interest. If you are compelled to get all of the subject exposed as well as possible, you will have to use an averaging method.

Take a meter reading on the brightly lit portion of your subject. Record it in your memory or on paper. Get a reading from the shadow-portion of the subject. Look at the

two readings and average them to arrive at a tolerable compromise. This is the best that you can do.

Working with shadows can be frustrating. The pain is lessened if you have a one-degree spot meter. Personally, I would feel naked without mine when doing outdoor photography. You can use electronic flash to brighten shadowy subjects. You might never consider using an electronic flash when the sun is shining and you have a gorgeous day for outdoor photography. Don't let the sun fool you. While a bright day provides adequate light to make exposures at fast speeds without the use of a flash, your pictures might suffer from shadows. When light is directional and is not diffused, shadows appear on many photographic subjects. An average photographer may never notice the dark spots, until the film comes back from the processing lab. If you use a flash, take several exposures at different settings to make sure you get an acceptable picture. Always remember to move in close to your shadowy subject for meter readings, unless you are using a spot meter.

That Horrible Harsh Light

Now that we've discussed the trials and tribulations of lack of light, let's talk about an abundance of light.

Do you remember, as a kid, when your parents or grandparents would take you outside to get a picture of you? Didn't they always position you so that you were looking into the sun? The belief seems to have been that if you were not squinting into blinding light, a good picture couldn't be taken. If this is still your perspective on outdoor photography, change it!

Full sunlight can be very harsh. It creates poor conditions for people pictures. Rays from the sun tend to bring out every blemish in a person's skin. Subjects are often forced to squint when the sun is very bright. Intense light can reflect off some skin tones to a point where hotspots are

created on your film. A nice, cloudy day is much more appropriate for good portraits. Get your subjects out of intense sunlight when taking pictures.

A professional photographer will sometimes use a large diffuser to soften the light on an outdoor subject. If you have an assistant or two and plenty of diffusing equipment, you can do this, too. Since you probably aren't well equipped for major photo shoots, you may have to compromise. The easiest way to beat harsh lighting is to move your subject into the shade. Another solution is to schedule your photo sessions early and late in the day, when the sun is not so imposing.

Shading Your Lens

It's not only important to diffuse light for your subjects, but also to protect your lens from harsh lighting. If sunlight streams into your lens, your film will suffer from sun flare. This is enough to ruin any picture, but it's easily eliminated. A lens hood will normally block enough light to keep sun flare from being a problem.

Watch Out

Some lenses, such as fisheye lenses and wide-angle lenses, don't work well with hoods. Since these lenses have such a wide perspective, you can see a hood on your exposed film. It will appear as a dark image on your prints. Before you buy a hood for a wide-angle lens, make sure that it will not interfere with your photography.

If your lenses don't already have lens hoods, install them. You can buy rubber lens hoods that will screw into the filter threads of a lens.

There are times when sun flare can be a problem even when a lens hood is in place. If you check your viewfinder carefully, you can see the flare. Putting your hand up to shade the lens is one way of solving this problem. Another way is to tape a piece of cardboard to your lens to act as a shading tool.

If you are taking pictures of people, you have to watch out for shadows around their eyes. A person's nose can also create a facial shadow. Getting rid of these unwanted blemishes is easy if you are willing to fire up your flash in bright sunlight. By combining electronic flash with existing light, you can eliminate shadows and create wonderful exposures.

Notice the shadow on the girl's face and how dark the mother's face is. A small burst of fill flash, fired from the left of the camera, would have made this a better picture.

Fill-in flashes can be used with sunlight or with other electronic flashes. The purpose of a fill-in flash is to produce even lighting for your subjects. A fill flash should not be too powerful or too close to a subject. Its effect should be subtle. In the case of outdoor photography, don't use a powerful flash for your fill-in work. A small, pocket-size flash will normally give you better results with fill-in work.

If you are using a powerful flash as your primary light source, inside or out, use a smaller flash to fill in the areas where you anticipate shadows appearing. For example, if your main flash is positioned to fire on the left side of a person's face, balance it with a fill flash that will illuminate the right side. This same principle applies with existing light.

The advantage that you have when using fill flash in sunlight is that you can see the shadows that must be eliminated. Aim your flash at the shadows and keep it far enough from the subject that the light will not create its own shadows. You will have to practice some to see what distances work best with your particular flash unit. The size and power of a flash determines what distances are acceptable for fill-in work. You may feel strange using a flash on a sunny day, but your pictures should turn out better if you do.

Raindrops Keep Falling on My Lens

Wet-weather photography can be hard on photo gear. If you are a die-hard shutterbug who is willing to venture forth in rain and snow for coveted pictures, you will have to take some precautions to protect your equipment. If your favorite time to take pictures is when it's raining, you might consider buying a waterproof housing for your camera. If you are an occasional rain nut, you can get by with some large plastic bags.

Sealing your camera inside a reclosable plastic bag is a cheap, effective way to protect the camera and lens from wet weather. You can cut a hole in the bag for your lens to peek through. Cut edges of the plastic can be taped to your lens. If your bag is big enough, you can operate your camera controls right through the plastic. If you are using a long lens and can't find a bag large enough to contain the lens and the camera, use two bags. Put the bags on from opposite directions, allowing the openings to overlap. Make sure that the overlapping is sufficient to block out rain and snow, then tape the bags together.

There's a Tree Growing Out of My Son's Head

When you are taking portraits outdoors, you have to pay attention to your backgrounds. That adorable picture you take of little Tommy might come back from the processing lab with a mailbox sticking up from behind the boy. Trees, signs, posts, and other objects frequently sneak into pictures. To avoid this, you have to check your viewfinder carefully.

Many photographers are so intent on their subjects that they fail to see the foreground and background of a scene. With the exception of poor lighting, bad composition is probably the major cause of bloopers with outdoor photography. You can use objects, such as trees, to enhance a picture, but they shouldn't be a distraction from your subject.

OOOH...

Insider Tip
Composition is one of the most important elements of a photograph. If you study your viewfinder carefully, you can guarantee good composition.

This is not a bad picture, but the trees are distracting. The photographer should have chosen a different camera angle or moved the subjects. Some light fill flash would have removed the shadows from the girl's face and the mom's arm.

Disasters for In-Camera Light Meters

In-camera light meters are like computers. They're great when they work and a real pain when they don't. Most in-camera meters are designed to work on an averaging basis. While this approach often works, there are many conditions where an averaging meter can be fooled. You can learn this the hard way by taking lots of pictures that are either overexposed or underexposed. Or, you can learn what to look out for and reduce your wasted film.

Sand and snow both have a similar effect on a reflective light meter. Since light is reflected strongly from sand and snow, most light meters are fooled. Spot meters are an exception, but other meters can't handle snow and sand well. If your subject is surrounded by reflective material, move in close for a meter reading. If you can't get a close-up reading of your subject, there are two other ways to improve your odds of getting a decent exposure.

Hold one of your hands out in front of your lens and take a meter reading from it. Do it with your palm facing straight up and then with it facing you. Take the two readings and average them for what should be a good exposure. A better approach is to use a photo gray card. This card is gray in color and is designed to be used with light meters. Gray cards come in a variety of sizes. A 5" × 7" card gives enough area for good meter readings, but you can get larger or smaller cards. Carrying a gray card with you is always a good idea, and it should be considered nearly mandatory when shooting in high-contrast situations.

You may not think a lot about trees when taking pictures, but you should consider what effect they will have on your photographs. Trees can interfere with good exposures in two ways. Shade created by trees can cause obvious lighting problems. A more subtle, but no less destructive, impact of trees on your exposure reading is the color of their bark. If you have a person standing in front of a grove of dark-colored trees, the dark color of the bark can make your meter go wacky. By the same token, light-colored trees, such as birches, can have a similar effect to the opposite extreme.

Jargon Alert

One-Degree Spot Meter: This is a light meter that is capable of taking a light reading from a very small portion of a subject. Spot meters can be used effectively even when they are a considerable distance from the subject where the reading is being taken.

Any time that your viewfinder is dominated by objects that are considerably different in tone and contrast from your subject, you are likely to get bad meter readings. Posing Aunt Nellie in front of a draping hemlock tree might make for a pleasant background, but the dark color of the evergreen will confuse your meter. There are only two ways to get around this type of problem. The best way is to invest in a spot meter. Your other option is to move in close and take a reading with your subject filling the viewfinder.

Insects and Stuff

In This Chapter

➤ Major magnification is possible with a bellows

➤ Life-size images come from macro lenses

➤ Ring lights are ideal for close-ups

➤ Use a focusing rail for really good pictures

➤ Nasty natural light can ruin your macro photography

➤ Extra light can improve your pictures

If you enjoy taking close-up pictures of nature, you owe it to yourself to get the right gear to work with. Don't expect it to be cheap if you opt for the really good stuff. However, there are some inexpensive options that you can turn to in order to see if the pursuit of tiny creatures is what your photography is meant to be. Crawling through leaves and grass on your belly in search of a praying mantis might not be your idea of fun. But if it is, you will learn about your equipment needs in this chapter.

A Bug's-Eye View of the World

To take pictures of insects and small plants, you need to get close to your subject. Trying to make an ant fill the frame of your viewfinder isn't easy with a standard lens. However, you don't have to spend hundreds of dollars on a macro lens to take occasional pictures of bugs. An inexpensive set of close-up rings that screw into the filter threads of lenses will get you started.

Close-up rings look like regular lens filters. They attach in the same way that screw-in filters do. The difference is in what the rings allow you to do. Once you install close-up rings on a standard lens, you can focus on items from a much closer distance. While this type of setup is too elementary for serious bug hunters, it is a good way to test your commitment to close-up work.

Bellows: The Next Best Thing to a Microscope

Bellows can be used with standard lenses, but they work best with macro lenses. By turning knobs, you can expand or reduce the length of a bellows. This is how you control magnification. The field of focus, or depth of field, you have when using a bellows is very limited. Magnification is what you are gaining. It is amazing what you can do

with a good macro lens and a bellows. Tiny objects, like the head of a pin, can be enlarged to become a main subject.

A bellows is not needed for general close-up work. A macro lens will give you plenty of good close-up pictures. It is not until you decide that extreme close-ups are what you want that you will need a bellows. Start building your collection of close-up equipment with less expensive items that you will use more often. As your interest in the area of close-up photography grows, treat yourself to a bellows.

Macro Lenses

Buying a quality macro lens will set you back several hundred dollars. The expense is worthwhile if you enjoy doing close-up photography. There is no other type of lens that will give you the quality and close-focusing ability that you get from a macro lens. You can consider a macro lens a specialty lens, but it can be used for all types of photography.

Jargon Alert

Macro Lens: This is a lens that is made to handle the requirements of high-quality close-up photography. Unlike other lenses, a macro lens is corrected for edge-of-field distortion. By eliminating this distortion, resulting photographs are better.

If you buy a 50mm macro lens, it will do anything that a standard 50mm lens can do. A 100mm macro lens can double as a 100mm telephoto lens. It's almost as if you are getting two lenses for the price of one. Why do macro

lenses give better close-up photos? They are corrected for edge-of-field distortion, while standard lenses are not.

When you buy a macro lens, you should receive an extension tube with it. This tube is not always used. When it is used, it is placed on the camera body first, and then the macro lens attaches to the tube. Adding the extension tube allows you to take life-size pictures of your subjects. This means that even very small subjects can fill your frame.

Standard lenses are generally designed to focus no closer than 18 inches from a subject. This is fine for many types of photography, but it won't cut the mustard with close-up work. When you work with a macro lens, you can practically put the lens on your subject and still get good focus. However, the field of focus will be short, very short. This makes taking crisp pictures a challenge. The lens is capable of it, but many photographers are not.

When you use a macro lens with an extension tube, you are able to record life-size images. Couple the same macro lens with a bellows, and you can get pictures that are 10 times the normal life-size.

When Is a Macro Lens Not a Macro Lens?

There is only one true macro lens, which works as I described in the preceding section. (Some manufacturers, however, call their close-up lenses micro lenses instead of macro lenses.) If you don't have a macro or micro lens, you don't have top-notch close-up equipment. Many lenses are sold with the hype of being close-focusing lenses. There is nothing wrong with these lenses, so long as you understand that they are not true macro lenses.

A lot of zoom lenses are made with close-focusing features. This is a good feature to have, but don't think that you can use a close-focusing lens to get the same results

you could with a macro lens. You can use a close-focusing lens to get decent shots of flowers and other small objects. But, if you want to capture tiny images on film, don't settle for less than a real macro lens.

Achieve Archival Quality Results with Ring Lights

Lighting can often be a big problem with close-up photography. You know by now that lighting is one of the biggest problems that photographers face. This fact looms even larger in the viewfinders of close-up photographers. Lighting subjects that are only an inch or so away from your lens calls for some special equipment and techniques.

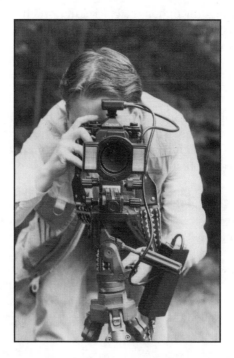

Ring lights around the lens provide even illumination.

There are many accessories on the market that are intended to aid close-up photographers in their lighting dilemmas. The most effective problem-solver for close-up lighting is a ring light. This is an electronic flash unit that mounts on the end of a lens. Since the flash surrounds the lens and illuminates a subject evenly, pictures are easy to take. Some ring lights are made so that either the entire flash will fire, or so that only a portion of the light can be fired. This allows more creative control of the lighting.

Ring lights are not cheap, and they are a specialty item. This is not something that a casual close-up photographer is likely to invest in. Serious shooters who buy ring lights will find, however, that they can't understand how they ever lived without one.

Another lighting option is a bracket that will hold two small flash units. The flashes can be placed to either side of a lens, allowing for good modeling light. This type of system works well when you are not pressed up tight against a subject. However, the system is not nearly as effective as a ring light for extremely close-up shooting.

Ring lights don't allow many options for dramatic lighting. Their purpose is to provide perfect lighting for recording images. For close-up work, no other lighting option is more effective than a ring light.

And Then There Was Wind

Wind is an evil enemy of close-up photographers who work outdoors. The slightest breeze can make it nearly impossible to maintain focus on a subject when you are working at high magnifications. Few things are more frustrating than composing a perfect picture and then having a little wind come along that takes it out of focus. How can you combat the breezy blues? Create your own wind screens.

In order to shoot close-ups in breezy conditions, you must block the wind. You can do this with a piece of cardboard or a spare jacket, for example. One problem you must still face is hauling your windbreak around with you. I have a solution for you.

I do a lot of natural close-up work. Wind is a frequent problem, but I have learned various ways to stop it from ruining an otherwise good day. I have a lightweight survival blanket that I carry with me. The blanket has a silver coating on one side and camouflage design on the other. By folding the blanket up, I can get it to fit into a small pocket in my photo vest. The blanket is pretty large when opened up, and it has grommets around the edges. With a little twine and some convenient trees, I can tie the blanket to the trees and stop all wind from reaching my subjects. The shiny side can be used to reflect light on a subject, and the camouflage side makes a good background when diffused with a short field of focus.

Over the years, I've used cardboard as a wind screen, but it's difficult to secure. Wind just blows it over. Some hardcore photographers carry little dome tents to protect their subjects from wind. The domes diffuse sunlight and allow outstanding pictures to be made. However, I wouldn't want to cover a bumblebee with a dome and try to get a shot.

The survival blanket is the best device I've come up with to use as a windbreak. I've used light stands to hold it in place when trees weren't available. You might come up with something that you like better than my blanket idea. If you do, use it. The important thing is to plan on having problems with wind and be prepared to deal with them.

Keep Your Close-Ups on Track with Focusing Rails

Aside from good lighting, getting crisp focus in close-up shots is one of the most difficult and critical aspects of eyeball-to-eyeball photography.

Since depth of field is almost nonexistent in extreme close-ups, the slightest movement or smallest miscalculation in focus can cause a wasted picture.

Under normal conditions, the focusing of a lens is usually done by turning the focusing ring on the barrel of the lens. This is rarely the case when doing extreme close-up work. An easier, and more effective, method is to move your camera back and forth until you achieve sharp focus. This can be done when you are hand-holding your camera, but human hands are not always steady. A better method involves using a focusing rail mounted on the head of a tripod.

Focusing rails share some similarities with bellows, but only in that the camera lens is moved closer to or farther from the subject by turning a knob. Bellows allow you to increase or decrease magnification.

OOOH... **Insider Tip**

The more you magnify, the less depth of field you have. This can be frustrating, but it can also boost your creativity. The soft focus that you get behind a subject will frequently create a beautiful background. With selective focus, you can blur out distracting backgrounds and keep your subject the main interest in your photo.

Focusing rails don't. When you mount your camera body to a focusing rail, you can set your close-up lens at the desired setting and adjust the focus of images with the rail system.

Since focusing rails allow you to move your camera forward or backward in minute increments, they make it possible to take great close-up photographs. The combination of solid tripod support and incremental focusing produces fabulous photos.

You can buy a good focusing rail with very little cash. All it consists of is a calibrated advance system for the movement of your camera. If you plan to do much close-up work, consider getting a focusing rail. The improvements in your pictures should be obvious once you use the rail system.

Eyepiece Magnifiers

Eyepiece magnifiers don't require a lot of discussion, but I would be remiss not to mention them. These units slip over the eyepiece of a camera. The advantage of using a magnifier on your viewfinder should be obvious. Since you are seeing your composition in a magnified state, much the same as looking at a slide with a magnifier, you can pick out faults in your composition more effectively.

Problems and Solutions Surrounding Natural Light

Natural light is what a majority of outdoor photographers rely on for good exposures. This type of light can be very effective, and it can produce pleasing results. However, there are times when existing light can cause some difficulties.

Many circumstances can come into play with natural light. A cloudy day can leave you in a bind when using a

slow film speed. Bright, harsh days can cast shadows, wash out subjects, and make your photos less than perfect. Early light is often cold in its color. Evening light is warm and embracing. Learning to use, and to overcome, natural lighting is a key element to the success of an outdoor photographer.

Close-up photographers who are serious about their craft often enter the field with an assortment of equipment. Part of this equipment includes diffusers, reflectors, and electronic flashes.

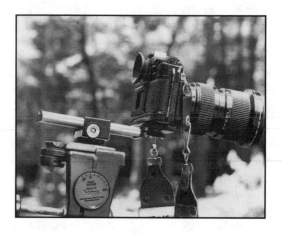

A focusing rail, like the one pictured, allows a camera to be moved along the rail for intricate focusing at high magnification. This is a very helpful aid when doing close-up photography with a macro lens.

We will talk about these items in a moment. Photographers who are willing to gamble on what the sun throws at them often come home with lackluster exposures.

People tend to think that sunlight is the best light to take pictures in. It can be, but it can also be the worst. The

position of lighting plays a vital role in successful photography. You can only control the sun to a certain extent. By choosing the hours of the day when you wish to work, you can predict, to some extent, where the sun will be and what it will do to your pictures. To come home with pictures that are consistently above average, you have to do more. The key is in how you use and manipulate your lighting.

Fill Light from Flashes and Reflectors

We talked about fill-flash lighting in the last chapter. The context was a little different, but the principles are the same. When you venture into the woods to take nature close-ups, you will often encounter difficult lighting situations.

OOOH...

Insider Tip
Carry a pair of tweezers with you when you do close-up photography in nature. The tweezers will allow you to move small objects without disturbing other elements of a scene.

Shadows may be heavy. Some subjects might be suffering from a low angle of sun, which can result in one completely dark side. Never fear. You can use electronic flash and a variety of reflectors to improve your shooting conditions.

If you are zeroing in on the perfect patch of ferns and notice that the sun's angle is going to leave some of them dark, flash the dark ones. The next time that you are lining up on the fluted lines of a mushroom's underbelly,

consider placing aluminum foil on the ground first. If you put foil under the mushroom, light will reflect up into the protected underside of the cap and give you much better lighting.

You can use white paper, reflective cards, aluminum foil, and a number of other items to bounce existing light around a subject. These same objects can be used to bounce electronic flash. A head-on flash shot is rarely flattering. Angled lighting typically works best. You can do this with flash equipment, but bouncing the light into place is likely to look more natural. As a nature photographer, you will probably want your shots to look as natural as possible.

Wildlife Photography

In This Chapter

➤ The curse of long lenses

➤ Face-to-face photography

➤ Bringing your subjects in close

➤ A day at the zoo

➤ Park profiles

➤ Pet portraits

Wildlife photography is my passion. Of all the types of photography I do, wildlife work tops my list of the most enjoyable. I hunted with a gun when I was a teenager and young adult. It didn't take long for me to put the guns on their rack and pick up my cameras in their place. The skill and thrill are the same, but the animals live to be seen again another day. Many photographers love putting wild animals on film. If you are interested in hanging pictures of deer, turkeys, moose, or squirrels on your wall, this chapter is for you.

Hocking Your House for a Long Lens

Do you need a long lens as a wildlife photographer? Yes, you do. Does it have to cost you an arm and a leg? No, it doesn't.

Telephoto lenses with fast apertures can cost a fortune. I was talking with a fellow photographer recently about this subject. The man with whom I spoke had just spent more than $8,000 for a 300mm, auto-focus lens. Its aperture is a blazing f-2.8, but still, eight grand is a lot to pay for a lens. My 300mm lens has an aperture of f-4. It's one stop slower than the fancy one my colleague bought, but it cost less than $700, and it is a top-brand lens. Mine is not an auto-focus model. Still, I have trouble spending four times what I spent on my first new car for a lens.

Long, fast lenses are ideal for wildlife work, but they are not mandatory. If you are willing to use film that is one stop faster, you can get the same pictures with a $700 lens that someone else will get with an $8,000 lens. Your picture will have a little more grain, and it may not be quite as sharp, but it will certainly cost a lot less when you factor in the price of equipment.

Most wildlife photographers require at least a 300mm lens. A 400mm lens is also good. If you can swing, and carry, a 600mm lens, you can find a use for it. If you plan to pursue wildlife, work toward getting the longest lens you can afford. Go for fast ones if you have money burning a hole in your pocket, but slower lenses can get the job done most of the time.

Getting to Know Your Subject, Up Close and Personal

You can reduce the expense of your lens collection if you are willing to become something of a hunter. Getting close to your quarry is the secret to using shorter lenses.

As a past bow hunter, I'm quite familiar with getting myself close to wild animals. My skills in the woods often allow me to shoot tight frames of animal portraits with a 200mm, f-2.8 lens. Many photographers would need a 600mm lens or longer to get the same shots I get with a 200mm lens.

> **Watch Out**
>
> A 500mm mirror lens is relatively inexpensive, and it gives you distance. Unfortunately, this lens also gives you poor picture quality, as a rule. Mirror lenses pack a long focal length into a short package. This is done by using mirrors as well as lens elements. The short length and large diameter of a mirror lens are distinctive. Most mirror lenses have fixed apertures, frequently at f-8. One drawback to a mirror lens is that it turns highlights into circles of lights, and this can be quite distracting.

The difference is my knowledge and love of animals. I know their habits and traits. This allows me to get in close without being detected. It frequently means sitting alone in the woods for hours to get a few shots, but the pictures are worth the effort, and sitting in the woods can be quite relaxing. I have fallen asleep on more than one occasion while on animal stakeout.

It can take years in the woods to truly understand animals. If your interests lie in wildlife photography, invest some of your money in books on animal behavior. Learn what your subjects do, when they do it, and why they do it. Then, get out in the field and study them. The more time you spend in the company of animals, the more you

will learn about them. You will find that the best wildlife photographers are the ones who know and understand the animals they photograph.

Spot Meters Are a Must

Spot meters are a must for wildlife photographers. It is important for you to accept the fact that no serious wildlife photographer will be caught without a spot meter. As you may recall, spot meters allow you to take light readings from very small portions of subjects that may be a great distance away. Since many forms of wildlife are difficult or even dangerous to approach, a spot meter should be used to calculate accurate exposures.

Calling All Animals

Learning to call wild animals in for close shots is a wonderful way to avoid paying big bucks for long lenses. You can master mouth-blown calls, learn to shake certain handheld calls, or simply use a special tape recorder to call in your subjects. An electronic game caller is the easiest type of call to use, and it often works best. Some states prohibit the use of electronic callers, so check your local laws before you buy or use one.

The electronic caller I use has a large, external speaker. It uses cassette tapes and will run off of internal batteries or by the cigarette lighter housing in a vehicle. Many types of tapes are available for calling anything from crows and coyotes to foxes and skunks. Bird photographers can capture some fascinating shots when using an electronic call, and animal photographers often get similar results.

Zoo Safaris: The Sensible Way to Get Super Wildlife Photos

Getting great wildlife photos can be a tough job. The need for long, fast lenses and a lot of time to invest in finding

animals may be more than what you want to commit to. This doesn't mean that you can't go out and get some dynamite animal portraits to hang on your wall. Go to a local zoo or wildlife preserve.

I have taken countless photographs of animals in the wild, but many of my best shots have been taken under controlled conditions. You would probably be surprised by the number of cover photos for magazines that are taken in zoos and game reserves. Professional photographers know well that they can reduce their time investment considerably by working with animals that are in some type of captivity. I'm not suggesting that a deer, for instance, will be standing in a small pen for these photographers. But, a herd of deer will probably be found roaming the grounds on only a few acres of an enclosed compound. This allows you to take natural-looking shots without spending days tracking a herd.

Zoo photography can yield some very nice pictures. Don't worry about fences. If you can get close to the fence, put a telephoto lens up to it until the lens hood is touching the wire mesh. Shoot at an open aperture, and the fence will never show up in your shot. The open aperture and telephoto lens not only eliminate the fence in front of you, but they blur out distracting backgrounds, as well.

There are many places where photographers can go to take pictures of semi-captive animals. Game farms that allow hunters to shoot animals for a fee are one place to go for photos of exotic animals. Many states have some type of animal rehabilitation area where injured animals are nursed back to health. These facilities offer good photo opportunities. The reward of stalking wild animals in a forest may not be equaled with game-farm and zoo shooting, but you will get faster results and probably better pictures.

Watch Out

Don't leave camera gear or an open camera bag alone around a duck pond. Ducks will often venture to a camera bag in search of food, and they have been known to peck away at expensive equipment and film.

Eye-to-Eye Contact

When you are shooting animal portraits, focus on the eyes of your subject. The eyes of an animal are often a drawing point to a photograph. If the eyes are out of focus, the whole picture is tainted. People viewing your photographs should be able to make clear, quick eye contact with your subjects. With a tight shot, the eyes and eyelashes should be focal points of the picture.

Stalking Elusive Wildlife in the Local Park

The local park may seem like an unusual place to go on a photo safari, but don't overlook the possibilities that exist. Many parks have duck ponds. Some of the ducks should be wild and colorful. These birds make tremendous photo subjects. Since people frequently feed the ducks, you should be able to get close to them and work with a medium telephoto lens.

Squirrels are usually abundant in parks. Taking a tight shot of a gray squirrel who is sitting on a branch eating a nut can be a lot of fun. Most park squirrels are not too timid, so super-long lenses are not needed. Common songbirds are another popular photo subject in parks. Depending on where you live, there may be a number of other animal inhabitants for you to work with.

Watch Out

Remember, wild animals are wild and can be dangerous if approached too closely.

Setting Photo-Traps for Wildlife in Your Backyard

If you are willing to invest a little time and money in outdoor attractions, you can get some terrific wildlife shots right in your own backyard. You don't have to live on a farm to pull in photogenic birds and animals. As long as you have some green space, woods, or fields, you can entice your subjects to come to you. This has many advantages. You can take pictures without ever leaving your house. There is no time wasted by traveling. Setting the stage for backyard photos isn't difficult, and it can be quite enjoyable.

I spent one winter shooting roll after roll of film from my living room couch. My lenses were 200mm and 300mm units. The subjects included blue jays, squirrels, raccoons, hawks, crows, deer, and other wildlife.

With various types of feeders and baits, I was able to turn my backyard into a wildlife photographer's paradise. Salt blocks brought in the deer. Bird feeders produced a variety of birds and squirrels. Cans of sardines brought the raccoons running. An electronic game call pulled hawks and crows in close. I didn't go to much trouble in setting up my wildlife reserve, but I did get hundreds of good pictures that were suitable for professional use. You can do the same thing.

I know of a few professional photographers who go to great lengths to create their own private wildlife habitat.

You can take the idea as far as you care to. Whether you simply hang a bird feeder and keep it full of seeds or plant your lawn in good game-bird cover, you can bring animals in close by providing food and habitat. It's hard to beat sitting in the comfort of your home while getting cover-quality wildlife shots.

Wonderful wildlife photos are possible with patience, persistence, and the right equipment. This white-tailed fawn was an easy target for a 300mm lens.

Do Pets Count as Wildlife?

Pet photography may not qualify as wildlife photography, but the subjects can be just as difficult to work with. Taking pictures of dogs, cats, birds, and other pets can be quite challenging. Pets are frequently the subject of photographs, but they are rarely captured on film in the most appealing manner. Like people portraits, many pet portraits look posed and stiff. This doesn't have to be the case.

Techniques for pet photography vary from pet to pet. It's one thing to get a head shot of a Saint Bernard and quite another thing to bring out the personality of a rat snake. When you want to take memorable pictures of your pets, you should spend enough time at it to get shots that are more than simple snapshots.

Dogs that are well-trained are easy to photograph. They can be told to sit and stay. If the training works, your subject is cooperative and easy to work with. You should pay attention to the background that fills your viewfinder. It should not be distracting. Use a portable backdrop or a plain, painted wall for the best-looking formal portraits. Outdoor shots can be done with natural backgrounds that are diffused with an open aperture.

When you are taking pictures of pets, get your camera at the pet's eye level. Never stand up and shoot down on a pet. Sit down, kneel down, or even lay down, but get your camera at eye level. Once you are in position, focus on the animal's eyes. Do your standard portrait shots, and then try to get some personality shots.

My wife had a cat many years ago that loved to lay on its back. It was a big, gray, fluffy cat. I got a wild idea one day that led to a cat picture that continues, to this day, to get a lot of attention. The cat was in its favorite position on our couch. I took an empty beverage can and put some juice from a can of sardines around the rim of the empty drink container. When I laid the can on the cat's belly, he gripped the can with both front paws and began to lick the oil from its top. My motor drive was spinning frame after frame of film through my camera. The resulting pictures were great. I could see the advertising copy under the pictures that would read, "good to the last drop." My creative cat picture is just one example of how you can set your pets up for pictures that are sure to produce comments and conversation.

When you photograph your pets, try to get some shots of them in action. If your dog is a swimmer and retriever, throw a stick into a pond and shoot frames of the dog in various stages of the retrieval process. Put your cat in a tree to get a different type of pet portrait. Hopefully, you won't need the local fire department to get the cat down. Let your animals act naturally and get as many candid shots as you can.

If your pets need to be photographed through glass, such as with fish, snakes, and other container-type pets, you should put a polarizing filter on your lens before shooting. Get the lens very close to the glass. If you have to use a flash, be careful not to allow it to bounce back at you from the back side of the tank. Put the flash above your subject and at an angle that will not cause bad reflections. Pet shops sell all sorts of background paper for aquariums, and this is a cheap, easy way to keep your tank pet looking good.

Wildlife and pet photography can be more difficult than basic photography, but the rewards are worth the extra effort for people who love animals. Focus on the fundamentals of photography at all times. Get to know your subject well, and use plenty of patience. Before you know it, you'll be taking first-class photos of all kinds of critters.

A Different Perspective

In This Chapter

➤ Manipulating Mother Nature

➤ Landscape lenses

➤ A monochrome approach

➤ Texture techniques

➤ Making satin with slow shutter speeds

➤ Getting in over your head

Landscape and scenic photography is a passion of many photographers. This type of work requires some wide-angle lenses and an eye for detail. Composition and lighting are the two most critical concerns of landscape photographers. Finding the right angle to shoot from can

be difficult. Getting rid of distracting electrical lines can be a real pain in the neck. Dealing with heat flare, sun flare, changing lighting conditions, and biting bugs are all part of a landscape photographer's life. Are the results worth the test of patience and skill? Yes, they are. Once you are outfitted for scenic photography, the trophies you hang on your wall will be a rich reward.

Use Filters to Enhance the Mood of Your Scene

A key element to any landscape photo is the lighting. You can use filters to manipulate Mother Nature and come home with some unique photographs. For example, you can turn an average day into a foggy one by putting a filter in front of your lens. If you don't like the color of the sky, you can change it with a graduated filter. Red filters can put a lot of contrast in your black-and-white shots. There are filters available for every occasion, and you should experiment with some of them.

Filter Facts

Film Type	Light Type	Filter Type
Daylight	Household	80-A (blue)
Tungsten	Household	82-C (blue)
Daylight	Photo Flood	80-B (blue)
Tungsten	Natural	85-B (orange)
Tungsten	Electronic Flash	85-B (orange)

Jargon Alert

Split-Field Filter: This is a filter that contains clear glass in the top half and a plus-diopter lens in the lower half.

When you use this type of filter, you can focus on a close foreground and a distant background evenly. The special glass in the lower half of the filter magnifies close-up subjects without distortion.

Strong sunlight can create a bluish tint on film. You can avoid this by using a filter rated as a 1A/B. Filters in the 81 series can also be used to cut down on blue tones. Filters in the low end of the series make the least correction, and those at the upper end provide the most. An 86B filter will take the blue out of shots taken in dense shade. All of these filters (1A/B, the 81 series, and 86B) are warming filters. Filters in the 82 series are used to cool down the red tones of daylight shots. They are just the opposite of the filters in the 81 series. A polarizing filter stops reflection problems and eliminates ghosts. Split-field filters allow you creative options.

When you work with black-and-white film, you can really see some strong changes in contrast when you use filters. A red filter, number 25, produces strong contrast between clouds and sky. It can darken blue, green, and purple tones while lightening red, yellow, and orange tones. A deep red filter, number 29, gives dramatic contrast between clouds and sky and can produce simulated moonlight when underexposed. A yellow filter, number 8, is used to give more natural exposures. Other black-and-white filters include yellow-green (number 11), orange (number 16), blue (number 47), and green (number 58). If

you own each of these filters, you are well-prepared for any type of black-and-white film manipulations.

From Fisheye to Compacted Telephoto Images

Choosing a lens for landscape work isn't difficult. Almost any lens will do, but some are better than others. My personal landscape lens is a 24mm. Some people use fisheye lenses for unusual perspectives. You don't have to be a scuba diver to use a fisheye. While fisheye shots do stand out, they are not the type of picture that most photographers want to create in bulk. If you use a fisheye lens, use it sparingly. Lenses in the 24mm to 35mm category work very well for most landscape work. There are times when a shorter lens is appropriate, and there are occasions when longer lenses are best.

An 85mm lens is a good all-around choice for landscapes and portraits. However, this lens will not give you the wide angle of view that you might want for some landscape work. You may want to use short-to-medium telephoto lenses for your scenics. Telephoto lenses compress a picture, which can be a positive effect. By compressing a picture, you bring all of the subject matter closer together. This occurs naturally when a strong telephoto lens is used. Two objects that are a reasonable distance apart will appear to be closer together. Zoom lenses are very handy for landscape work. A lens with a range of 35mm to 70mm will cover a lot of ground as a versatile lens. Personally, I would keep at least one wide-angle lens in my vest for landscapes, but you may find that this is not necessary for the types of shots you take. Outfitting your camera bag is something that will take time, experimentation, and personal choices.

Insider Tip

OOOH...

Avoid shooting long land-scapes on hot, reflective days. Heat rays and haze will soften your images.

Use Black-and-White Film for Dramatic Landscapes

In this age of color film, many photographers have never taken a black-and-white photograph.

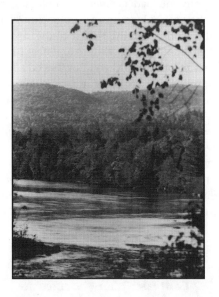

This landscape photograph is a typical composition. The tree limb in the right corner adds depth to the picture, while the river winds through the frame and leads your eyes to the mountains.

This is a shame. Colorless, black-and-white film is capable of producing powerful pictures, especially in the field of landscape photography. Some shots scream out to be recorded on black-and-white film.

When you work with high-contrast film, you must learn to see a little differently. The dark and light tones you have in black-and-white film require you to see in terms of contrast rather than color. Learning to do this is difficult for some people. If you don't work on contrast with black-and-white film, your shots will be gray and dull. This is one good reason to use filters. They bring out the contrast.

Why would anyone load a camera with black-and-white film when they could load up with color film? There are many good reasons for doing this. If you want to develop your own prints, black-and-white is a perfect film to start with. It's easy to process and you don't need a lot of expensive equipment, like color analyzers. A more important reason is that some landscapes look better in black-and-white. The stark contrast that can be brought out on black-and-white film can't be touched by color film. No, you won't see the beautiful colors of autumn foliage with black-and-white film, but you can derive a lot of pleasure from looking at high-contrast photos. By mixing high contrast with low-key features, you get outstanding black-and-white photos.

Jargon Alert

Contrast: This is the difference between the densities or degrees of light present in an image.

Those Confounded Electrical Lines

Nearly all landscape photographers have experienced the frustration of electrical lines ruining the composition of an otherwise fantastic photo. How can you get rid of the lines? You can't; you have to work around them with telephoto lenses and changes in position. Eliminating a fence in a zoo is easy; erasing electrical lines from your composition is not. Of course, you could carry a chain saw around and cut the poles down, but this would be hazardous to your health.

When electrical and phone lines get in your way, you have to compromise. Look for a shooting position that is higher or lower in elevation. Try some telephoto lenses to see if you can crop the lines out of your composition. Can you shoot from a different angle? Of all the obstacles you encounter as a landscape photographer, electrical lines are sure to be one of the most consistent and difficult to deal with.

Lay on Your Back for a New Perspective—But Beware of Birds!

How many times have you seen photographers laying on their backs and aiming their lenses skyward? I would guess the answer has to be not often. One of the ways to make your photographs special is to shoot them in a creative manner.

Most photographers see landscapes from an upright position. If you get on your back and look up, you will see an entirely different scene. It is this type of individual effort and creativity that will make your photographs win prizes and stand out. Let me tell you a quick story about this type of thing.

For an unusual perspective, lie on your back and shoot straight up with your camera. You will see the world around you in a very different way.

I was shooting stock photography for a New York agency several years ago. My agent requested pictures of fall foliage. This seemed strange to me, since so many photographers are ravenous on this subject. My agent said that the client wanted something special, but didn't know what. I went to work.

When I started my assignment, I took typical foliage shots. Some had covered bridges in the foreground, and others had churches. All of the shots looked good, but they didn't have the special quality I wanted. Then I got an idea. I laid down on my back and shot straight up into the canopy of fall leaves. Becoming infatuated with my new angle, I switched to a zoom lens. I zoomed the lens during a slow exposure to create a collage of color. I probably stayed on my back for close to an hour, experimenting with different lenses. The results of my up-in-the-air shoot were gorgeous. The agent and customer were delighted. By looking at the world from a different angle, I found success.

Have you ever seen a photograph of a playground that was taken from the ground up? Can you imagine what the Eiffel Tower would look like if you laid under it and looked up? There are many landmarks and tourist locations that have been photographed so often that there is nothing fresh about them. Get on your back and shoot toward the sky to create a noteworthy print. This type of approach is not always sensible, but it can produce some eye-catching prints.

Use Side Lighting to Bring Out Texture

If you ever take a course in photography, one of your subjects will likely be texture. This is a favorite topic among photography instructors. To get strong texture in a picture, you need side lighting. Sunlight shining on tree bark from behind a camera will not give you nearly as much texture as light coming from one side. This is easy to prove. Bring a piece of bark into your home and shine a light directly on it. Look at the bark through your camera lens. Move the light to one side and peek through your viewfinder. You will find that side lighting enhances the texture tremendously.

When you are shooting landscapes, texture can be an important element. This is particularly true of your foreground subjects, but it can also pertain to your primary subject. Let's say that you are photographing an old barn covered in wood siding. If the barn is lit by light from behind your camera, the siding will be flat. Wait until the sun moves to the side of the barn, and all the grooves and texture of the siding will then jump out at your film.

As with most types of photography, landscape photography is often done best when the light is not shining from directly above or behind your lens. Angled lighting produces the most pleasing photographs. For texture, insist on side lighting.

Warm Up Your Images with Afternoon Light

The time of day you choose to work with your camera will affect the outcome of your pictures. Morning light tends to be cold, while afternoon light is warm. A sprawling hay field will almost always photograph better in the golden glow of late afternoon lighting. Sand dunes also photograph best in warm afternoon sun.

You can use filters, as we have discussed, to warm morning light. Sometimes you may want the cool tint of morning light, but most scenics look better in warm light. In general, concentrate on your landscape photography in the afternoons or use warming filters to change the mood of morning light.

Turn Flowing Water into Satin

You have probably seen pictures of streams and cascading waterfalls where the water had a satin-like quality to it. This effect is created by using a slow shutter speed. To stop flowing water in its tracks, you have to shoot at a faster speed. However, most waterscapes look best when the water is slowed down and turned to satin. The shutter speed that works best will depend on the speed of the water. In some cases, a shutter speed of 1/60th of a second will work fine. Other occasions call for a slower speed. To be on the safe side, start with 1/60th of a second and take several exposures at increasingly slower speeds.

To capitalize on the satin effect, you should have your camera mounted on a tripod. Your goal is to get everything except the water in crisp focus. Since the water is the only part of your scene that is moving, a slow shutter speed will not affect other elements of the photograph. To make sure you get what you want, bracket your exposures in a downward trend. Start with an exposure around

1/60th of a second and make additional exposures with slower speeds. I think you will like the results.

Fishermen's Float Tubes Can Give You a Frog's-Eye View of the World

Perspective is everything in a scenic picture. Just as you must have your camera at eye level for portraits, you should have it at subject level for most landscapes. Depending upon your personal preferences, landscapes that interest you might involve water. When this is the case, you need a boat, canoe, or float tube to take advantage of unique composition.

I've done a lot of aquatic photography over the years. Not underwater photography, but water-surface work. Much of this work has involved close-ups of reptiles, birds, and plants. One of my favorite modes of transportation is a wide-body canoe. However, there are times when sitting in a canoe puts me too high above my subjects.

When I was asked to bring back pictures of pink water lilies, I decided to use a float tube. If you are not familiar with these tubes, they are similar to the old inner tubes that kids used to float around on. Modern versions are covered in canvas and equipped with seats and pockets. They are intended for use as fishing vessels, but they work great for photographers. However, don't use them in alligator-infested water!

When I went out into a pond with my float tube, I was at eye level with the lilies I wanted to photograph. My low angle of approach gave the pictures a unique quality. If I had taken the shots from the bank with a telephoto lens, they would not have been nearly as good. Even using my canoe would have resulted in a downward composition. By being low in the water, I got picture-perfect shots.

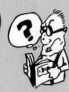

Jargon Alert

Ghost: A photographic ghost is a flare spot on an image that is caused by the reflection of intense light. A polarizing filter will aid in avoiding ghosts.

Your float tube or canoe will probably see more action with wildlife or nature photography, but don't overlook this mode of transportation for landscapes and scenics. You can bet that few photographers go to the trouble of getting at water level for interesting shots. This is just one more trick that will turn your shots into wall-hangers instead of album dust-catchers.

Glossary

Aberration A lens fault where light rays are scattered and degrade a photographic image.

Abrasion marks Marks made on the emulsion of film that resemble scratches. They can result from dirt or dust on the film while worked with either in your camera or in your darkroom.

Acutance The objective measurement of how well an edge is recorded in a photograph.

Adapter ring A device that mounts on a lens to allow you to install further accessories, such as a gelatin filter holder.

Additive process When lights of different colors are combined you have an additive process. If equal amounts of three primary colors are combined, the result will be white.

Aerial perspective You might think that this relates to aerial photography, but it doesn't. It is the impression of depth shown in a scene that is conveyed with the use of haze.

Angle of view A measurement that has to do with the widest angle of light rays seen by a lens that forms a suitably sharp image at the film plane. To determine this measurement, a lens must be set at a focus level of infinity. In lay terms, the angle of view is what you can see

when looking through your viewfinder. Or, in some cases, what the camera sees that you don't. Not all cameras offer a what-you-see-is-what-you-get view.

Aperture A part of a lens that opens and closes to allow light to get to the film. You can see the aperture work if you look in a lens that is not mounted on a camera body and rotate the aperture ring.

Aperture priority When an in-camera meter takes its reading based on the aperture setting you have chosen, the camera is in aperture-priority mode. For example, if you want a diffused background, you would set an open aperture, say f-2.8, and your camera would choose the proper shutter speed to produce a good exposure.

ASA American Standards Association. It is a measurement of film speed and relates to the sensitivity of a particular film.

Available light Light that is on a photographic subject naturally, such as sunlight in an outdoor setting.

Back lighting Lighting that is placed behind a photographic subject.

Barn doors Hinged metal flaps found on photographic studio lights that allow you to control the volume and direction of lighting produced by the lights.

Base A term applied to the support material on an emulsion, which is usually plastic or paper.

Bellows A device used for close-up photography. It is a lighttight, extendible sleeve that is infinitely adjustable between its shortest and longest extent. Extreme magnification is possible when a bellows is used.

Bounce flash A procedure in which light from an electronic flash is flashed onto a reflective surface and then lights a subject. As an example, you might bounce your

flash off a wall in your home to light the face of a subject in a portrait.

Bracketing A method in which you take more than one picture of the same scene using different exposures. Typically, the first picture is taken at what is believed to be the ideal exposure. Subsequent exposures are taken one stop faster and one stop slower to ensure a successful exposure.

Bulb setting A setting on a camera that allows the shutter to remain open for as long as the shutter release is depressed. By using this feature, you can produce timed exposures.

Bulk film Film that is purchased in a long roll and cut and loaded into canisters or other containers for standard use. Bulk film is cheaper than pre-packaged film containers, but it can be difficult to load. If the film is exposed to light during the loading process, it will be fogged and ruined.

Burning in A darkroom term that means you are increasing the exposure on a portion of a photograph by leaving it exposed to enlarger light while the rest of the picture is shaded or masked.

Cable release A device that allows you to depress the shutter button of your camera without touching the camera body. A cable release should be used when you are shooting at slow shutter speeds. By not touching the camera, you reduce the risk of camera shake and distorted images.

Cassette A container that 35mm film is loaded into when it is prepared for use in a camera. Another name for this container is magazine.

Changing bag A lighttight bag equipped with openings for your hands and arms. A changing bag can be used

to load film into film tanks or cassettes without the need for a darkroom.

Coating A thin layer of material placed on the surface of a lens to reduce flare.

Color compensating filter A filter used to alter the color of light under various circumstances. Many ranges of compensating filters are available for all types of occasions.

Color contrast The subjective impression of the difference in the intensity between two close colors.

Color head A darkroom device used as part of an enlarger. It is an illumination system that has built-in, adjustable filters or light sources that are used when making color prints.

Complementary colors Colors that when combined produce white light.

Composite image An image that is made from more than one image source. For example, a multiple exposure is a composite image; so is a sandwiched image.

Compound lens A lens that is made with more than one element, allowing for optical corrections to be made.

Contact sheet A sheet of exposed, developed photo paper that contains images from all negatives produced from one roll of film. Contact sheets are used to preview exposures in a darkroom and to allow evaluation of various darkroom exposures.

Critical aperture The point of aperture opening where a lens produces the best image quality. The setting is usually somewhere around the middle of the range of settings.

Cropping A procedure where unwanted items are deleted from a picture. Cropping can be done before a

picture is taken by using a zoom lens, switching to a longer lens, or by moving closer to the subject. It can be done after a photo is taken by enlarging the image in a darkroom.

Dedicated flash An electronic flash designed to work with one particular camera. The flash is connected to the camera with a sensor that allows for automatic flash exposures.

Depth of field The distance at which subject matter remains in sharp focus during the picture-taking process. Open aperture settings reduce depth of field. Closed-down apertures extend depth of field.

Diffuser A material that breaks up and diffuses incoming light.

DIN Deutsche Industrie Norm. It is a method of identifying film speed and sensitivity.

Diopter Refers to the light-bending power of a lens.

Dodging A term used in connection with darkroom work. It is when a portion of photo paper is shaded during an enlarger exposure. This allows the unshaded areas to be exposed longer, giving a different type of contrast and look.

Electronic flash A portable, artificial light source used to illuminate photographic subjects. The light output from an electronic flash is perceived as daylight by film, so no corrective filters are needed when using daylight film.

Emulsion A light-sensitive material composed of halides that are suspended in gelatin. It is used in the making of both film and photographic paper.

Exposure This word relates to the amount of time that film or photographic paper is exposed to light.

F-stop Aperture settings are rated in f-stops. A low numbered f-stop, such as f-2.8, is an open aperture, and a high f-stop, such as f-16, is a closed-down aperture.

Film speed rating A measurement of a film's sensitivity to light. It is most often referred to as either an ASA or ISO rating, each of which will be the same. A film with an ASA rating of 200 will have an ISO rating of 200. Another scale used for rating film speed is the DIN rating.

Filters Devices that are placed over lenses on both cameras and enlargers to alter light and images. They can be used for corrective purposes or to create special effects.

Flare Light that is scattered or reflected and that does not form an image. It can be reduced with lens coating and lens hoods.

Flash guide number A unit of measurement that allows you to determine the proper aperture setting for your camera when electronic flash is being used as a light source.

Focal length The distance between the center of a lens and its focal point.

Focal plane The point at which a lens forms a sharp, crisp image.

Focal point The point on either side of a lens where light enters parallel to the axis of coverage.

Focus The point where light is converged by a lens.

Gelatin filters Filters that are made from dyed gelatin. They are inexpensive, but scratch easily.

Grain A light-sensitive crystal that is normally made of silver bromide. The faster a film is, the more grain it has. For the clearest pictures, a slow film speed should be used to reduce the effect of grain in photo enlargements.

Haze A vapor of fog, smog, or smoke in the air. Photographically speaking, haze can be created by harsh light falling on the glass element of a lens.

Hyperfocal distance The minimum distance at which a lens can record an image clearly while the lens is set on a focus range of infinity.

Incident light Light that is falling on a subject, rather than light being reflected off of a subject.

Incident light reading A light reading taken with a light meter that shows the amount of light illuminating a subject.

Infinity A point in distance when light rays from objects are parallel.

Internegative A negative that is made on special color film for making copies of prints or for making prints from slides.

ISO International Standards Organization. A standard rating for film speed and sensitivity.

Joule A unit of measurement for the output of an electronic flash. It is equal to one watt-second. By using this form of measurement, you can compare the power of various electronic flash units effectively.

Kelvin When you see temperature ratings given in Kelvin degrees, you are seeing the standard unit of thermodynamic temperature. It is arrived at by adding 273 degrees to a centigrade temperature reading.

Latent image An invisible image that exists on exposed emulsion. Once the emulsion is developed, the image becomes visible.

Lens flare The result of scattered or reflected light that is non-image forming that reaches an emulsion. It can be reduced with lens coating and lens hoods.

Lens hood A device on the front of a lens that protects the lens surface from unwanted, non–image-forming light that can cause flare. Some lens hoods are built-in on lenses, and others are accessories screwed into the filter threads of a lens.

Luminance The amount of light emitted by or reflected from a surface.

Macro lens A lens that gives high-quality performance when shooting close-ups. Some manufacturers call them micro lenses.

Masking A technique where a mask is used to block light from part of an emulsion. Masks can be used in filter holders for special effects when taking a picture. They can also be used in a darkroom when making prints with an enlarger.

Negative A photographic image that is comprised of reversed tones. In other words, light objects are dark and dark objects are light when looked at on a negative. When a negative is printed, the colors become positive and appear normal.

Negative carrier A holder that works in conjunction with a darkroom enlarger to hold a negative or slide.

Normal lens A normal lens is one with a focal length equal to the diagonal of the film format. What this amounts to is that a normal lens produces a picture that has a normal or everyday perspective and angle of view. Wide-angle lenses and telephoto lenses distort these qualities and are therefore not normal.

Open flash When a camera shutter is held open with a timed-exposure and flash is fired periodically on a subject, the process is known as open flash.

Panning Moving your camera in a smooth arc to follow the motion of a moving subject while keeping the subject in the same position in your viewfinder.

Photo lamp A tungsten lamp used to light photographic subjects that gives a color temperature of 3400 degrees Kelvin.

Primary colors Red, green, and blue are primary colors, as are cyan, magenta, and yellow. Primary colors are colors that when grouped in threes can be used to make any other color. When mixed together in equal proportions by the additive process, they make white. If the subtractive process is used, they make black.

Pulling film A process where the development time for film is shortened.

Pushing film A process where the development time for film is extended.

Reciprocity failure Light-sensitivity lost during exposures that are either very short or extremely long is known as reciprocity failure.

Resolution The capability of a lens to distinguish between items placed closely together. The higher the resolution of a lens, the better the lens is.

Ring flash An electronic flash that is shaped like a doughnut and attaches to the end of a lens.

Safelight A light that can be left on in a darkroom without affecting light-sensitive materials. Most safelights are either red or amber in color.

Sandwiching When two or more images are combined to make a single image. This process is usually done in a darkroom with an enlarger, but accessories can be purchased that allow you to sandwich slides and shoot the composite picture with your camera.

Scrim A screen placed in front of lights to reduce their output.

Shutter priority One form of an automatic camera. When an in-camera meter takes its reading based on the shutter-speed setting that you have chosen, your camera is in shutter-priority mode. For example, if you want to stop the motion of a Ferris wheel, you would set a shutter speed of 1/250th of a second and your camera will choose the proper aperture setting to produce a good exposure.

Single-lens reflex camera A camera that uses a mirror to allow photographers to see exactly what is focused on their film.

Slave unit A device used with multiple flash setups that allows independent flashes to fire in unison with the primary flash that is serving a camera.

Snoot A device that is fitted to the head of a photo lamp to narrow its beam of light. Snoots are often used when lights are intended to highlight a model's hair.

Spot meter A handheld, independent light meter that takes reflective light readings from very small portions of a subject. It is the most accurate reflective light meter you can own.

Stepping down This means that you are reducing the aperture size or the shutter speed for your exposure.

Subtractive process When the combination of primary colors, dyes, or filters that absorb light are used to produce a black image.

Thick negative A negative that is dark or that has a dense image.

Thin negative A negative that has a thin density and is pale.

Transparency Another name for a photographic slide. It is a positive image meant to be viewed by transmitted light, such as that from a light table or slide projector.

Tungsten light Light that is created by heating a filament of tungsten to a temperature where it emits artificial light.

Vignetting The gradual fading of the edges of an image to either black or white.

Index

Symbols

A